IMAGES
*of America*

# CHULA VISTA

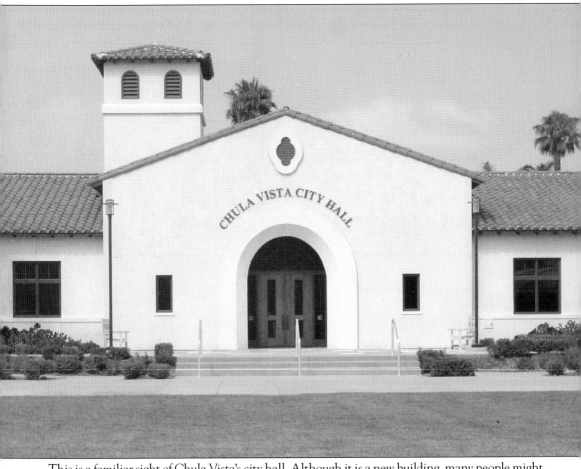

This is a familiar sight of Chula Vista's city hall. Although it is a new building, many people might not realize it. When city officials decided to completely rebuild city hall recently, they kept the design the same as the one built in 1951 that it replaced. So this is Chula Vista's brand-new "old" city hall on Fourth Avenue. (Courtesy Manny Ramirez.)

ON THE COVER: Chula Vistans love a parade! Led by majorette Gwen Ellis, the Sweetwater High School band marches south on Third Avenue, just crossing F Street. Pictured in 1945, the Bank of America was soon to move farther north on Third Avenue. Chula Vista's city hall next door would be replaced by a building similar to the one above within a few years. (Courtesy Chula Vista Public Library Local History Collection.)

IMAGES
*of America*

# CHULA VISTA

Frank M. Roseman and Peter J. Watry Jr.

ARCADIA
PUBLISHING

Published by Arcadia Publishing
Charleston SC, Chicago IL, Portsmouth NH, San Francisco CA

Printed in the United States of America

Library of Congress Catalog Card Number: 2007935834

For all general information contact Arcadia Publishing at:
Telephone 843-853-2070
Fax 843-853-0044
E-mail sales@arcadiapublishing.com
For customer service and orders:
Toll-Free 1-888-313-2665

Visit us on the Internet at www.arcadiapublishing.com

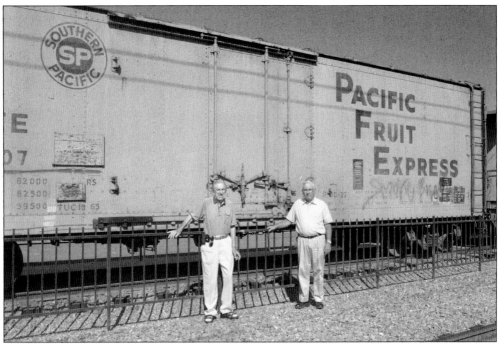

The authors, Frank Roseman (left) and Peter Watry, stand next to a Pacific Fruit Express "reefer." These refrigerated cars, loaded with 300-pound blocks of ice, carried Chula Vista's lemons to the far corners of the country for three-quarters of a century. (Courtesy Manny Ramirez.)

# CONTENTS

# ACKNOWLEDGMENTS

This book would not have been possible without two gentlemen. In 1980, John Rojas Jr. and some others formed the Chula Vista Historical Society. For the next 10 years, John gathered historical material, wrote a monthly bulletin, copied photographs, recorded stories from the old-timers, and collected artifacts. A great deal of the historical information and photographs in this book would have been lost had John not collected it in the 1980s. In 1993, the Chula Vista Library director asked Frank M. Roseman to create a museum in a small empty building in Memorial Park. Roseman, a retired Rohr Aircraft employee, along with Rojas, created and organized the Chula Vista Heritage Museum. Gradually photographs and artifacts were transferred from Rojas's garage to the new museum and a storage site at the Civic Center Branch Library. Thanks to Frank, John's photographs and artifacts had been safely put into archival boxes and indexed before his unexpected death in 2000.

This book would also have not been possible without Donna L. Golden, our Chula Vista Library local history librarian. The photographs were eventually transferred to Donna's care. The problem was that John Rojas had not left much information as to where he had copied those thousands of historical photographs. To whom did the copyrights belong? Through long and tedious study, Donna gradually sorted out which photographs belonged to the library (in terms of copyrights) and which did not. This book could not have been done without that knowledge, and Donna was also primarily responsible for the book's organization.

The Chula Vista Heritage Museum is under the direction of the Chula Vista Public Library. Thus encouragement and important permissions were required and generously supplied from library director David Palmer and staff members JoAnn Jonas and Jeri Gulbransen. Randal Fai supplied the needed technical assistance.

Debbie Seracini, our Arcadia Publishing editor, was a source of constant encouragement, help, and grossly exaggerated assurances that we could do it.

To tell the whole story, we needed to buy some photographs from other archives. Kim Kilkenny, executive vice president of Otay Ranch Company developers, generously funded those acquisitions and permissions.

All the photographs in this book not otherwise noted are the property of the Chula Vista Public Library Local History Collection.

# INTRODUCTION

The original residents of what is now Chula Vista were, of course, American Indians. For two centuries, these Native Americans have been referred to as Diegueños because that is the name the Spanish gave them. Today most of the bands are adopting the Native American name Kumeyaay.

The first Europeans to see San Diego were the Spanish on the ships commanded by Juan Rodríquez Cabrillo, which sailed into what is now San Diego Bay in 1542. Cabrillo was exploring the Pacific Ocean area north of New Spain (Mexico). He stayed a few days, declared the land for Spain, and sailed on.

Sixty years later, the second group of Spanish appeared. In 1602, Sebastián Vizcaíno sailed into the bay, named it "San Diego," and sailed on.

It was 167 years before the Spanish next set foot in San Diego, and this time, they came to stay. After learning that the Russians had been working their way along the Alaskan shore hunting furs, the Spanish decided that if they wanted to claim California, they needed a permanent presence. So a Spanish party led by Fr. Junípero Serra marched overland to San Diego in 1769. On July 1, 1769, they proceeded north through what is now Chula Vista on their way to San Diego. There were relatively few Spanish. Their job was to indoctrinate the Native Americans with the Spanish culture and ways. They established missions from San Diego to San Francisco, and besides Christianizing the Native Americans, they also taught them to grow the kind of food eaten by the Spanish and to make buildings and furniture and clothing. The Spanish had brought seeds and animals with them. It turned out that California was one vast grazing ground, and soon the missions were handling thousands of head of cattle. The Native Americans did the work at the missions.

Under Spanish rule, the king or his representative assigned land. Since the missions were most important, most grazing land was assigned to the missions. What is now Chula Vista and the South Bay was assigned to the soldiers of the Presidio for grazing their animals. They called it El Rancho del Rey, the "King's Ranch." Today a development in Chula Vista is called Rancho del Rey, which was the first name of Chula Vista.

"New Spain" became the country of Mexico in 1821. The Mexican government allowed private ownership of land, and soon large land grants were being given to favored men and women. One such land grant, over 26,000 acres, was given to John Forster, an English trader who had married the sister of Pío Pico, the last Mexican governor of California. Called El Rancho de la Nación (the "National Ranch"), the land grant included what is now National City, Bonita, and the western half of today's Chula Vista.

The United States took over California following the Mexican-American War in 1848. The Mexican land grants were allowed to continue as private property. In 1868, the National Ranch was sold to Frank Kimball and his brothers. Frank Kimball set about developing the land into a productive, American-style farming community.

First, he created National City in the northern part of the rancho. National City was to be the commercial town of the plan, providing the banks and supplies for the agricultural part. Second, the 5,000 acres south of National City was designated the agricultural farm of the Rancho—the area eventually to become Chula Vista.

But Kimball needed two things to have Chula Vista become a commercial agricultural success. He needed a way to transport the product to distant markets—and in the 1870s, that meant a railroad—and he needed a dependable source of water.

After many disappointments, Kimball finally got the Santa Fe Railway to build a rail line to National City. The Santa Fe now had a vested interest, so they financed the building of the Sweetwater Dam at the end of Bonita Valley, which was finished in 1888. Kimball now had his water source.

Kimball had experimented with crops for years. He decided Chula Vista's crop would be lemons because the weather near the coast was perfect for lemons—not too hot or too cold. With the completion of the Sweetwater Dam in 1888, Chula Vista blossomed very quickly. Right in tune with the general explosion of citrus production in Southern California in the 1890s, Chula Vista soon had several thousand acres of lemon groves. Indeed, by 1910, Chula Vista boasted of itself as being the "Lemon Capital of the World."

In 1910, the population of Chula Vista was only 550 souls, but it was decided that Chula Vista should be a city, and so in 1911, they adopted a charter and became the City of Chula Vista, and Chula Vista will soon celebrate its centennial.

All did not go well in the lemon groves. Drought caused problems, as well as the normal problems of bugs and diseases among the trees. In 1913, a real blow came—the Big Freeze. Over the next three decades, more and more farmers started switching to row crops or truck farming. Celery, above all, became the largest revenue earner by 1940; but tomatoes, cucumbers, lettuce, beans, and other crops were also grown.

On the verge of World War II, Chula Vista's population was 5,240 in 1940, and the area was still primarily an agricultural community. Its large Japanese farming population was soon swept away to relocation camps in the desert in April 1942; they remained there for the duration of the war.

In 1940, a man named Fred Rohr started a small business in San Diego making parts for airplanes. Fred's specialty had always been sheet metal work, and he had built the nose cowling for Charles Lindbergh's *Spirit of St. Louis*, which flew across the Atlantic in 1927. In 1941, he began building a new factory on the Chula Vista bay front. His specialty was the nacelle, or the metal covering that surrounds an engine on an airplane. He started with some 800 employees in the summer of 1941. By the height of World War II, he was employing some 9,000. Thousands of B-24 bombers and PBY Catalina flying boats were made in San Diego, and Rohr made the nacelles for them. With all those people now working at Rohr, several wartime housing developments had to be built and built quickly, so farm lands were soon covered with homes.

The tens of thousands of servicemen who passed through San Diego in World War II (navy and marines) remembered the nice area, and so in the years following World War II, more and more people moved to Chula Vista. Soon the lemon orchards and the celery fields were taken out and replaced by homes and streets and schools and businesses. By 1960, the last packing plant had closed, and soon there were few remnants of Chula Vista's agricultural past. Chula Vista became a bedroom community for the San Diego area. The population has grown from about 5,000 in 1940, to 44,000 in 1960, to 135,000 by 1990, and is some 220,000 as this is written in 2007.

This is Chula Vista's story in photographs and words.

# One

# THE EARLY YEARS

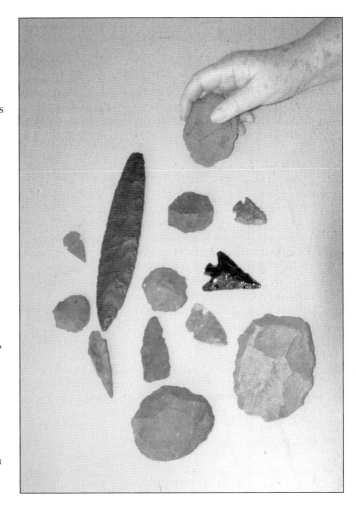

The Kumeyaay Indians occupied Chula Vista for thousands of years before the Europeans came. They have been called Diegueño Indians for some 200 years because that is what the Spanish named them. In California, the Spanish tended to name the local Native Americans after the local mission where the Native Americans were taught Spanish ways, in this case the San Diego Mission. Recently, similar to many Native American groups in the United States, many of the local bands now prefer to be called by the Native American word, Kumeyaay. Like most Native Americans, they were still in the Stone Age in terms of their tools. These scrapers, choppers, and arrowheads were all found locally. Doug Hughes has been collecting these Native American rock tools and arrowheads in the Chula Vista area for over 40 years. (Courtesy Manny Ramirez.)

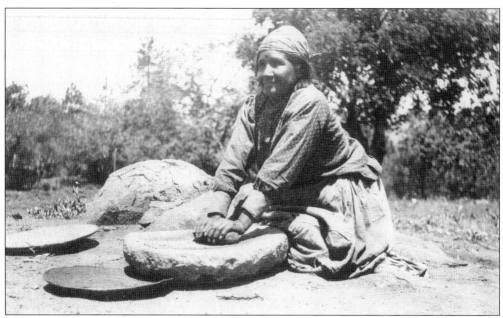

A Kumeyaay Indian woman is grinding acorns, which were a staple food of the Kumeyaay. Gathered in the fall when they ripened, acorns could be stored for long periods of time. After grinding the acorn into flour, it was cooked, usually to a mush consistency, like hot cereal. While staying in Chula Vista, which had few oak trees, they could process grass seeds in a similar fashion. (Courtesy San Diego Historical Society.)

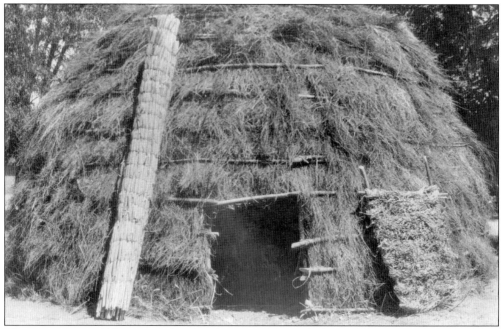

The Kumeyaay were hunters and gatherers, moving around the area with the seasons and food sources. Therefore, their housing needs were simple and temporary. This structure, called an *ewaa*, is made from bent willow branches and covered with various grasses or bushes. This example was photographed in the 1920s by anthropologist John P. Harrington. (Courtesy Museum of Man.)

The leader of the party of Spaniards that came overland to San Diego in 1769 to indoctrinate the Native Americans with Spanish culture and ways was Fr. Junípero Serra, a Franciscan priest. His party passed through what is now Chula Vista on July 1 on their way to establish their first California mission in San Diego.

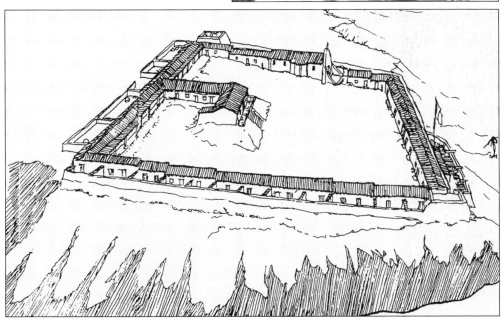

While the Spanish missionaries were establishing their San Diego Mission a few miles to the east, the Spanish soldiers established their presidio (fort) on what is today known as Presidio Hill, just above what was to become Old Town. Later, when they were more confident of their safety, they moved down the hill to establish the pueblo now known as Old Town. (Courtesy Jack S. Williams.)

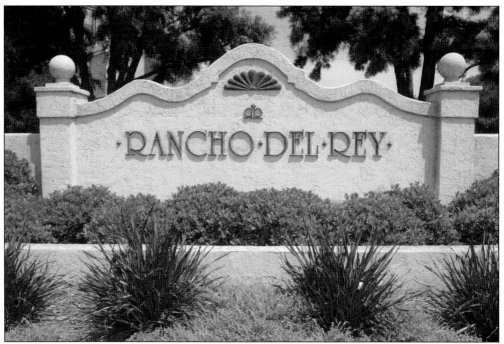

The land of what is now Chula Vista was assigned to the soldiers of the Spanish presidio for grazing their horses and cattle. They named this grazing land El Rancho del Rey, or the King's Ranch. Today a major development on East H Street is named Rancho del Rey, the first name of Chula Vista. (Courtesy Manny Ramirez.)

When the Spanish came, California was a vast grassland, perfect for raising cattle. When California became part of Mexico, cattle raising continued to flourish. The hides and tallow were traded with passing American and British merchant ships for wonderful goods that could not be made locally. What is now Chula Vista and the South Bay were part of that trading process.

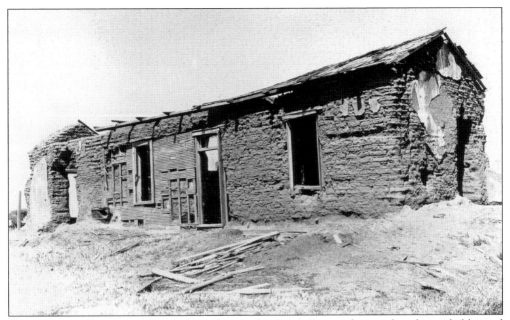

Santiago Aguello was a very active rancher in the South Bay, and it was he who probably used the grassland that is now Chula Vista for grazing his cattle. His adobe home was one of the few homes in the immediate area and was located at what is now the intersection of Main Street and Interstate 5. This is the remains of his 14-room adobe about 1950.

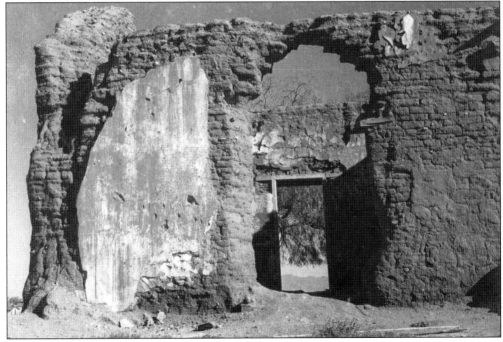

This is another photograph of the Aguello adobe not too long before it was razed to make way for the Montgomery Freeway (now Interstate 5) in the early 1950s. It was the last remaining reminder of the days when the Mexican flag flew over Chula Vista. Aguello was later instrumental in helping John Forster gain title to neighboring El Rancho de la Nación after the American takeover.

John Forster was an English trader who, shortly after he arrived in Southern California, married Isadora Pico, the sister of Pío Pico. The Picos were a wealthy Mexican family in the San Diego area, and Pío Pico was the last Mexican governor of California. As such, he granted his brother-in-law several large land grants, including the 26,000-acre El Rancho de la Nación (National Ranch). (Courtesy Anthony "Tony" Forster.)

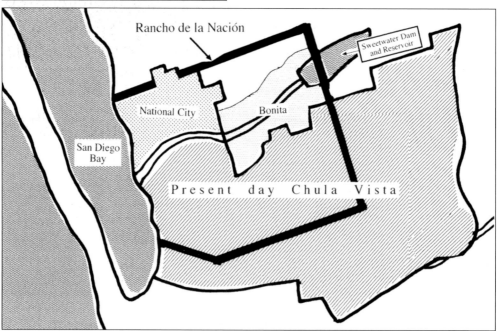

The heavy line is the boundary of El Rancho de la Nación, some 26,632 acres. Today the communities of National City, Bonita, and the western half of Chula Vista are located on that Rancho. Chula Vista is a very unique name. People suppose it to mean "beautiful view," but in Spanish, *chula* is sort of a slang term meaning cute or a pretty little thing.

Frank Kimball purchased El Rancho de la Nación (National Ranch) in 1868. The rancho had only been used for grazing cattle. Kimball was determined to create a modern, American-style agricultural community from the rancho. First he created a town and called it National City. (Courtesy National City Library.)

For anyone who has ever purchased a property in National City, Bonita, or the western half of today's Chula Vista, their grant deed will begin by noting in which lot of which quarter section of Rancho de la Nacion their property lies.

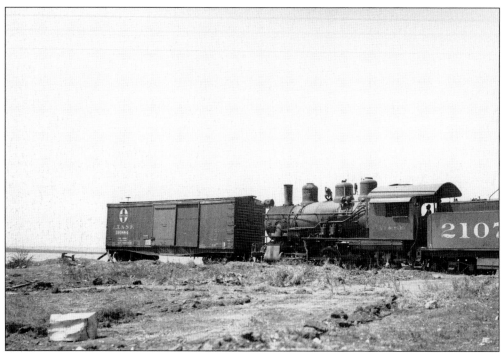

In the 1870s, Kimball needed two things before he could make his rancho into a modern agricultural community. First, he needed a railroad to transport the product to distant markets, and second, he needed a source of dependable water year-round in an area where 10 inches of rain a year is considered normal. After many disappointments, he finally got the Atchison, Topeka, and Santa Fe Railway (above) to build a rail line to National City. (Courtesy San Diego Historical Society.)

Frank Kimball built this depot for the Santa Fe Railway in National City in 1882. It still stands today and is used as a rail museum. The Santa Fe named the railroad built between National City and Colton, where it met the main Santa Fe tracks, the California Southern Railway. The Santa Fe Railway owned the California Southern. (Courtesy National City Library.)

16

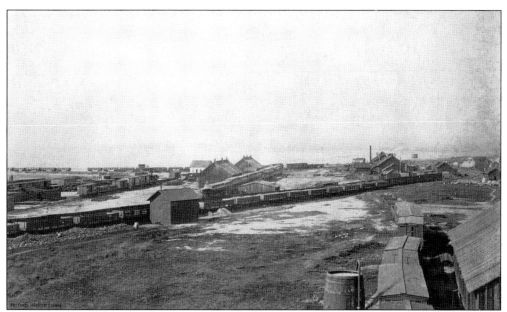

These are the Santa Fe Railway workshops in National City. In the early years, Chula Vista's lemons would have been shipped from here. Today the railroad itself, now the Burlington Northern Santa Fe, still has a freight yard behind the old depot, and the railroad is still active in hauling freight—Kimball's original intention 140 years ago. (Courtesy San Diego Historical Society.)

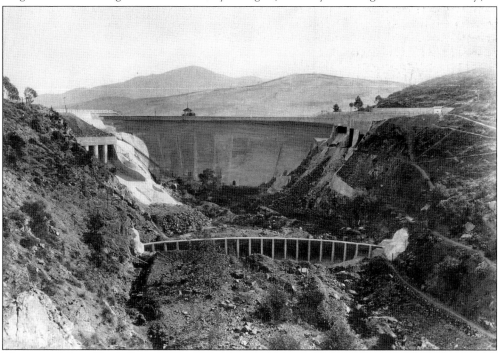

The second thing Kimball needed to create an agricultural community was a dependable source of water. The Santa Fe Railway now had a vested interest in the rancho's success, too, so it financed the building of the Sweetwater Dam at the end of Bonita Valley. The dam was completed in 1888 and at the time was the highest arch masonry dam in the country.

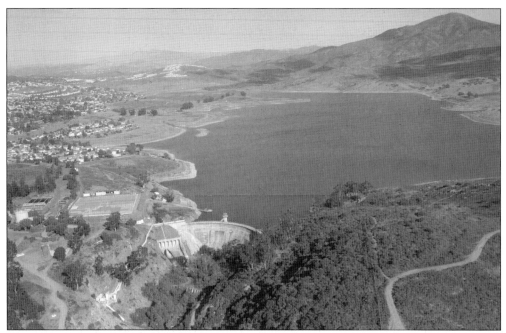

The Sweetwater Dam is an example of what dams are all about. In a land where average rainfall is only about 10 inches a year, a dam is needed to build up the reserve of water. The Sweetwater Dam was the first dam built in San Diego County. Completed in 1888, it is still serving National City, Bonita, and the western half of today's Chula Vista. (Courtesy Manny Ramirez.)

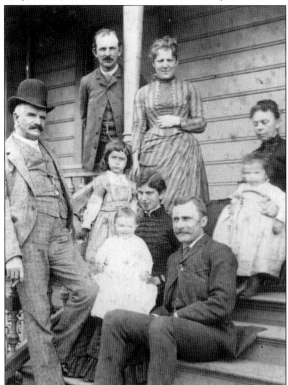

Now with a railroad and a dam, Kimball was ready to develop his farm, the 5,000 acres south of National City. Kimball had to give the Santa Fe Railway 10,000 acres to entice them to build their line to National City, and that included all of what was to be Chula Vista. A Santa Fe planner, William Dickinson, designed Chula Vista. He is at the left edge of this photograph. As Dickinson was fated to die in a few years, his son-in-law Charles Boal, standing by the post, succeeded him

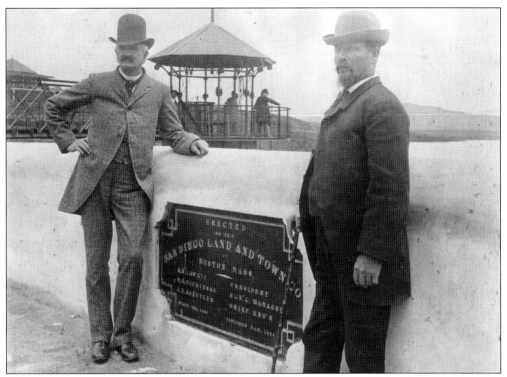

The two men responsible for Chula Vista were Frank Kimball (who had the vision) on the right and William Dickinson (who did the planning) on the left. They are standing on top of Sweetwater Dam at the time of its dedication in 1888.

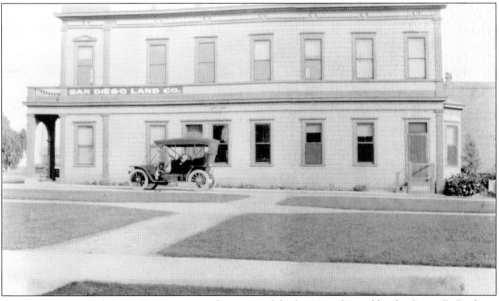

San Diego Land and Town Company was the name of the business formed by the Santa Fe Railway to develop Chula Vista. Later it was shortened to San Diego Land Company. William Dickinson was its president, and he laid out the streets and lot boundaries. The western parts of Chula Vista's main streets are still in the quarter-mile grid pattern that Dickinson laid out in 1888.

The rains in 1916 were unprecedented, and many areas suffered disastrous floods. While the Sweetwater Dam did not break, its anchor mountain gave way, and the Sweetwater Valley flooded. This photograph shows the trolley tracks that used to cross the Sweetwater Valley near Second Avenue. They were never replaced. Thereafter, the trolley used the railroad tracks along what is now Interstate 5.

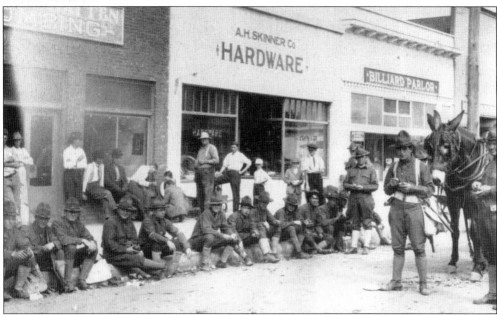

In 1911, Mexico was undergoing a revolution. A group trying to take advantage of this attempted to conquer Baja, California. Having taken Mexicali and Tecate, they marched on Tijuana. Fearing that the fighting might spill over on the American side, an army troop from Fort Rosecrans marched to the border. Here they are taking a break in the 300 block of Third Avenue. (Courtesy San Diego Historical Society.)

# Two

# LEMON CAPITAL
# OF THE WORLD

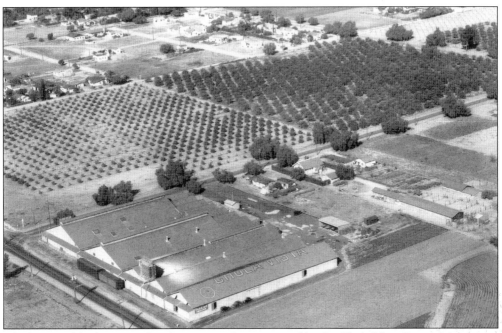

The largest of the lemon packinghouses was the one owned by the Chula Vista Citrus Association, a member of the Sunkist Growers. It was on the southeast corner of Third Avenue and K Street. A Bank of America branch is there today. The dark, wide line across the bottom left part of the photograph is Third Avenue, south being to the right. Two Pacific Fruit Express reefers (refrigerated railroad cars) can be seen waiting to be loaded. After 1920, Chula Vista was served by the San Diego and Arizona Eastern Railroad, an affiliate of Southern Pacific Railroad. Pacific Fruit Express was jointly owned by Southern Pacific and Union Pacific Railroads. "Chula Vista" is written on the packinghouse roof with an arrow pointing to the local airport on the bay front.

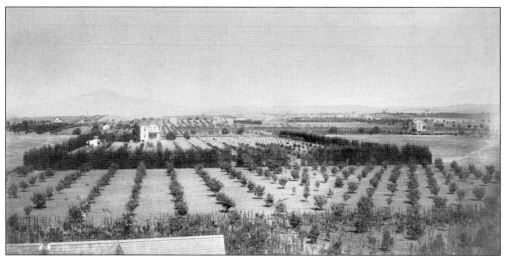

This is Chula Vista, perhaps in the 1890s, when the first lemon groves were being planted. The view looks east toward Mount Miguel. Actually, planting orange trees, usually sour oranges, begins lemon groves. The root systems of lemon trees are weak, so after a few months, lemon branches are grafted on to the orange tree stock.

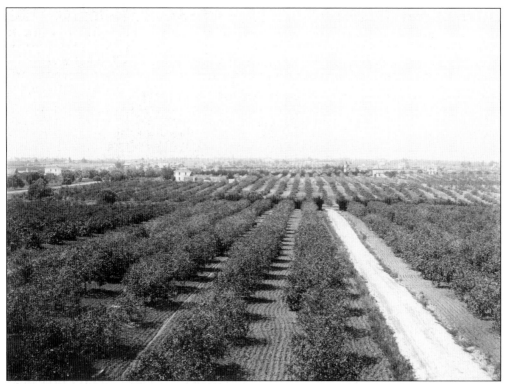

Taken perhaps between 1900 and 1910, this view looks west down the Boltzes' driveway toward the bay. The Boltz ranch was just north of F Street, seen along the left edge. Among the houses seen, two can be identified along Second Avenue as the Cordrey House (1888) and the Davidson House (1894). Both are still standing and are beautiful examples of Chula Vista's "orchard homes," homes built in the lemon orchards. (Courtesy San Diego Historical Society.)

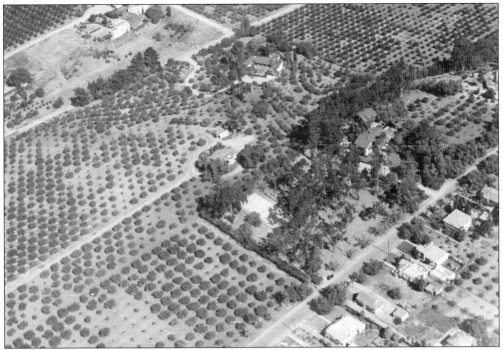

This aerial view of the Montebello Ranch lemon orchard centers on the Boltz ranch. That is F Street in the lower right-hand corner, just east of First Avenue, and E Street is at the top of the photograph. Although this was probably taken in the 1920s, most of these houses are still in existence.

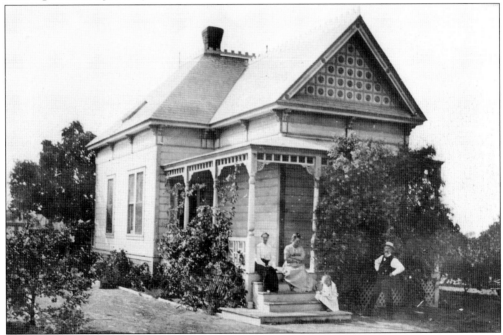

This is a typical, smaller lemon ranch house early in Chula Vista's history. The gentleman seems to be dressed in his Sunday best. Farm lots in Chula Vista, as originally sold in 1888, ranged from 5 to 40 acres.

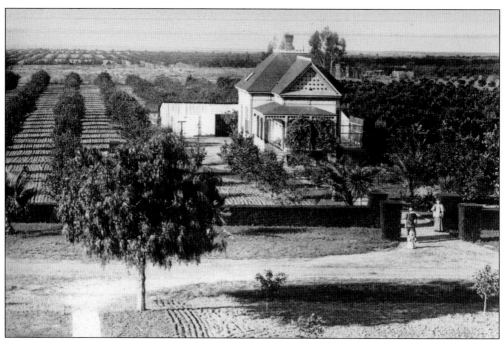

Elisha and Olive Gavin purchased this five-acre lemon ranch in 1893 from Herman Fulton. Thereafter referred to as the Gavin Ranch, it was located at what are now Sierra Way and Fifth Avenue.

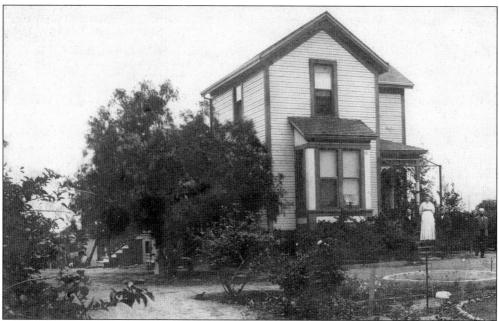

Frank Howe's home and lemon grove was located at the corner of Third Avenue and J Street. His grove was on the five acres he purchased in 1894. The property remained in the family until 1961. An important requirement established by San Diego Land and Town Company was that an original buyer had to build a substantial house within two years. The company did not want speculative, boom-or-bust buying.

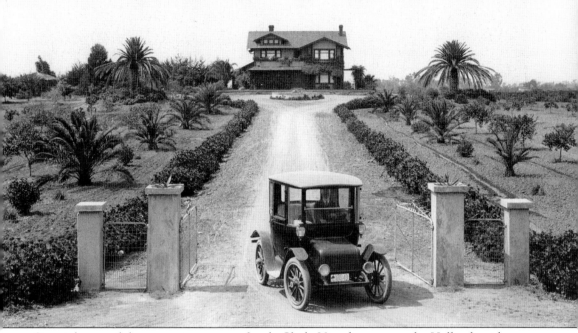

Certainly one of the most picturesque of early Chula Vista homes was the Holland residence, located on Fourth Avenue near L Street. Judging by the automobile, this photograph was taken around 1910. The lemon trees in the groves are only a few years old. These lemon trees may have a rough time ahead, as droughts occurred from time to time and lemon trees need vigilant watering. In 1913, the Big Freeze occurred when the temperature first dropped below 28 degrees, ruining many of the lemons, and then dropped to 20 degrees, killing the younger and weaker trees. One solution to cold temperatures still being used elsewhere is the use of smudge pot heaters in the fields. Some farmers started switching to growing annual row crops. Certain insects and diseases are known to attack weak plants, including lemon trees. To combat this, an insectary, which still stands, was built at 511 G Street to grow "good bugs" to fight the "bad bugs." (Courtesy San Diego Historical Society.)

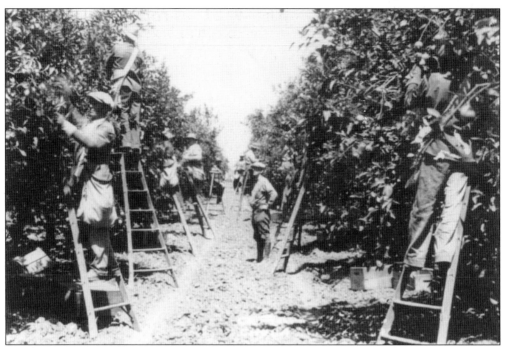

A typical lemon-picking crew is seen at work early in the 20th century. The field manager standing in the middle is Walter Cary. Cary was later the last general manager of the Chula Vista Citrus Association. His son Richard still lives in Chula Vista.

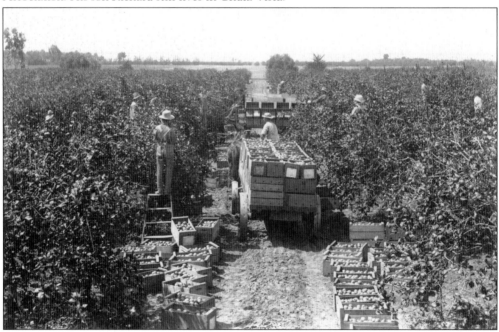

Lemons ripen all year long, so this photograph could have been taken any time in the year, probably about 1901 or so. Note the wagons pulled by horses. Lemons are actually still green when they ripen, and if picked green, they can be gassed with ethelyn gas and steam in the packing plant to turn them yellow. (Courtesy San Diego Historical Society.)

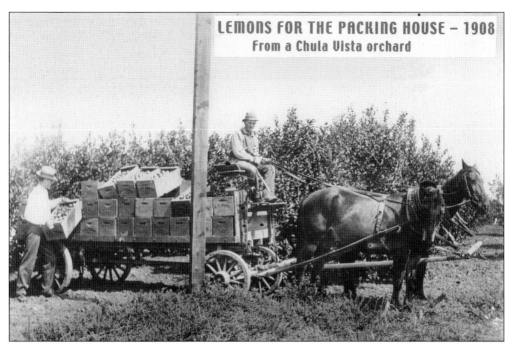

LEMONS FOR THE PACKING HOUSE – 1908
From a Chula Vista orchard

Lemons are being picked in the groves for delivery to the packinghouse. The pickers put the lemons in strong field boxes, as can be seen, and many of those field boxes survive today. Many field boxes can be seen in the previous photograph.

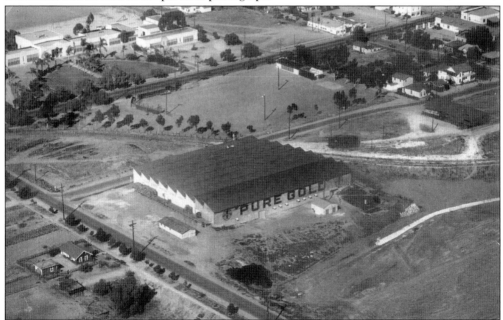

A rival of Sunkist, the Mutual Orange Distributors packinghouse can be seen from the air. This photograph dates to around 1930, before Mutual Orange Distributors expanded. That is Fourth Avenue running diagonally along the bottom, and F Street runs across the top of the photograph. F Street School can be seen at the top of the photograph. Between the two is the old baseball field, now the site of the Chula Vista Police Station.

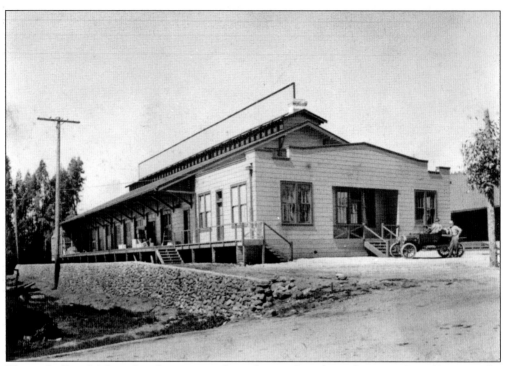

This is the Randolph packinghouse, an independent packer, about the time of World War I. The independent packers went out of business when they could no longer compete with the large co-ops like Sunkist and Mutual Orange Distributors.

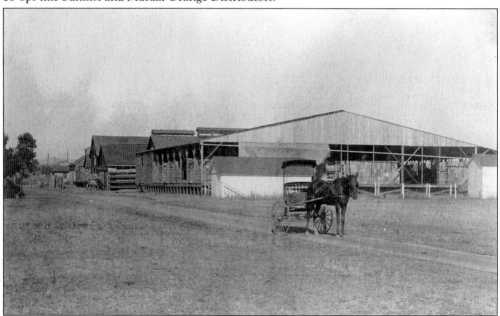

The Leach packinghouse, shown in the early 1900s, was eventually bought out by the Chula Vista Mutual Lemon Association, affiliated with Mutual Orange Distributors. The horse and buggy are on what became Center Street, and the Mutual Orange Distributors plant shown in the aerial view on page 27 was built just behind the photographer's position on Fourth Avenue.

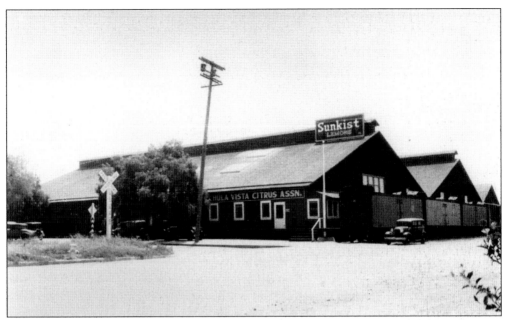

The Sunkist plant in the 1920s was operated by the Chula Vista Citrus Association. Note the reefers (refrigerated railroad cars) waiting by the siding to be loaded with Chula Vista lemons and bound for all parts of the United States. The reefers were kept cool by 300-pound blocks of ice in bunkers at each end of the cars. These Pacific Fruit Express cars were all painted orange. The Sunkist plant was painted brown at this time.

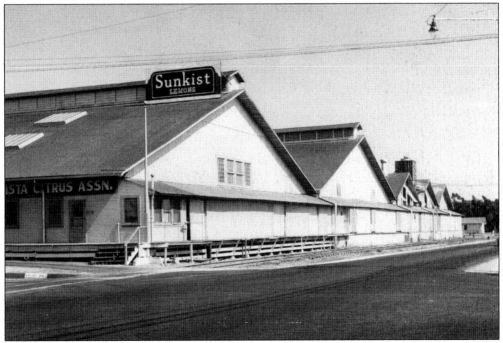

The Sunkist plant, now painted white, is shown in a later view looking south on Third Avenue at K Street. Processing lemons is usually a year-round business, but note the absence of any reefers waiting to be loaded. Today this is the parking lot for a Bank of America branch.

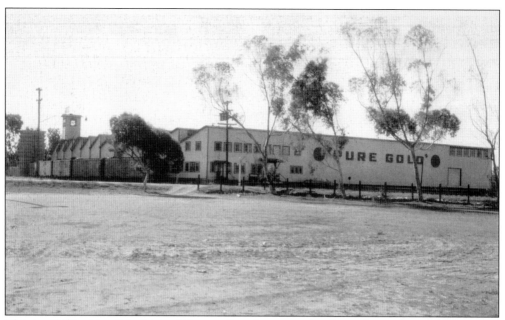

This is a 1960s view of the Mutual Orange Distributors packinghouse located near the corner of Fourth Avenue and F Street. The view is from F Street looking south. A rival of Sunkist, they had the motto "Pure Gold." The plant has been expanded from the one shown on page 27. The rail line ran up F Street to Fourth Avenue, then angled south to Third Avenue. The reefers are waiting for their load.

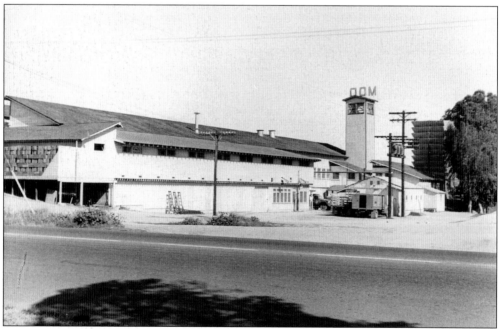

The Mutual Orange Distributors packing plant letters "MOD" can be seen atop the cooling tower. The view looks east across Fourth Avenue. Both this plant and the Sunkist plant ceased operations in 1960, the end of Chula Vista's lemon history. This structure was razed in 1965 for a condominium project.

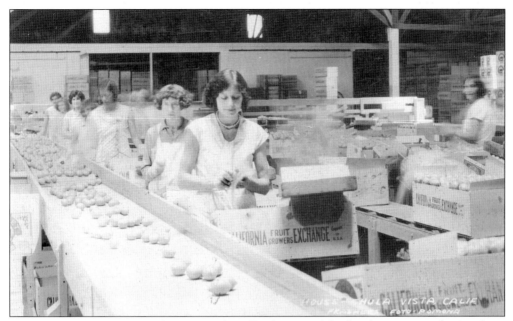

California Fruit Growers Exchange was the official name of the first big co-op in the Southern California citrus industry. They used the motto "Sunkist," hinting that California citrus had been kissed by the sun. Later they changed their name to Sunkist Growers, as it is today.

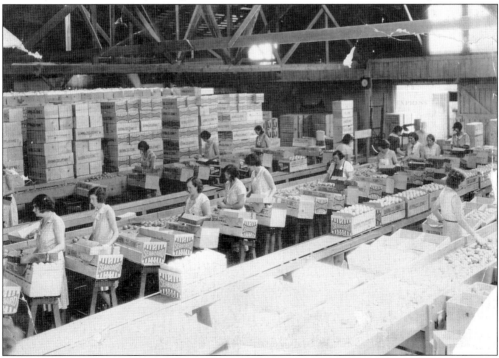

The Sunkist packing plant was where lemons were washed and sorted before packing. They were sorted by the appearance of the outside skin into three grades of quality. The crate labels indicated the quality of the lemons. The label on these crates is "Seaboard," indicating their third level of quality.

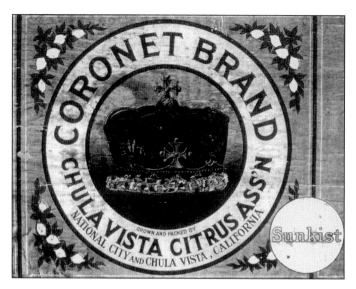

Coronet was one of the many brand labels used by the Chula Vista Citrus Association. The "Sunkist" written on the lemon image indicates their top-quality lemons. Notice in the previous photograph, there are no lemons labeled "Sunkist" on the Seaboard label, indicating they were third-level quality lemons. The Chula Vista Citrus Association began operations in 1918 and ceased operations in 1960. (Courtesy Sunkist Growers.)

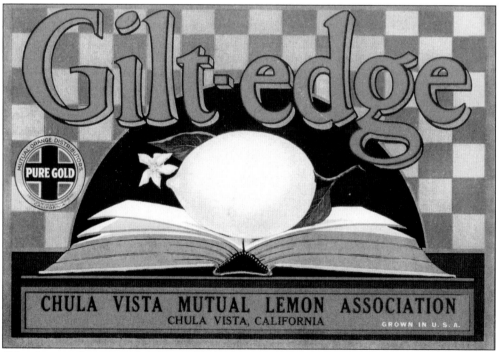

Gilt-edge was the top-quality brand label of the Mutual Orange Distributors, operated by the Chula Vista Mutual Lemon Association. The Chula Vista Mutual Lemon Association began operations in 1926 and ceased operations in 1960.

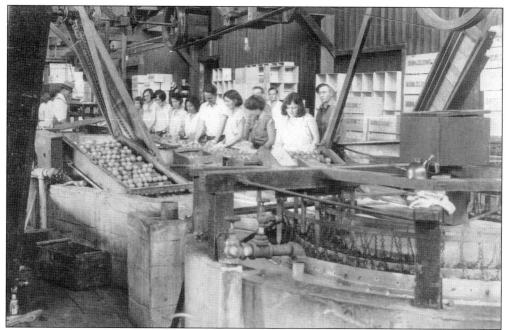

A World War I–era photograph taken inside the Sunkist packing plant shows lemons being washed and culled. Lemons that were blotchy on the outside are just as good on the inside as the ones that look nice, but housewives do not want to buy unattractive fruit. So they are culled (removed), as these people are doing, and used in the many by-products of lemons.

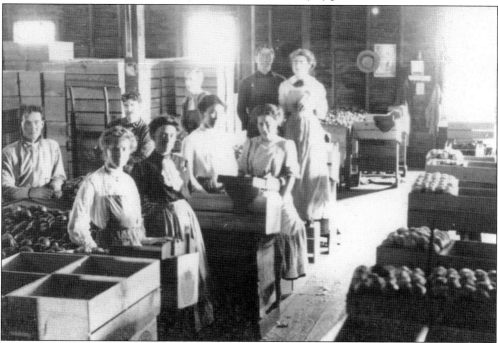

In one of the earliest packing plants in Chula Vista, the Leach Packinghouse, workers are processing lemons. Much of the labor in a modern lemon packing plant is similar, although machines have replaced most labor.

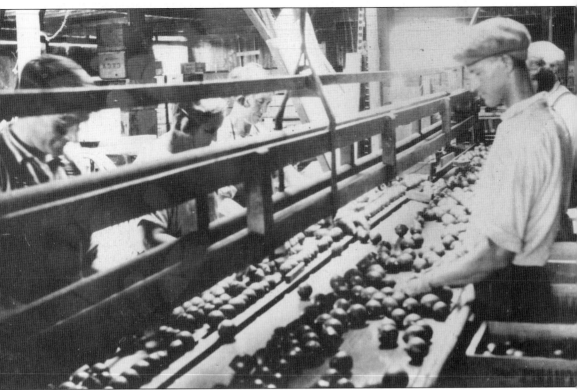

Workers are sorting lemons in the Mutual Orange Distributors packing plant in 1936. Lemons are sorted by size as well as by appearance. Some markets want large lemons; some want small lemons. But when a buyer opens a box of lemons, he wants them all to be of a similar size. That is still true today. A box may say "count 36" on the outside, indicating there are 36 lemons in that box, which means the lemons are larger than a "count 42" box—the same size box containing 42 lemons. Pickers carried sizing rings with them in order to pick the size of lemons the plant wanted that day. Now, as it has always been, citrus, including lemons, are sorted by three grades of quality, characterizing the lemon's outside appearance and size.

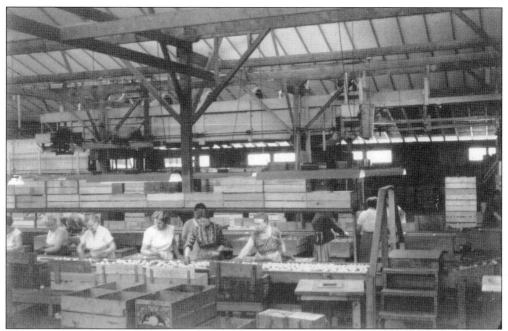

Lemons are being sorted for shipping inside the Mutual Orange Distributors packing plant. Note the wooden crates for shipping lemons. They have a divider in the middle, but they are not built nearly as heavy as the field boxes used over and over by the pickers in the field. Note also the gilt-edge label on the crate, marking Mutual Orange Distributors' top lemon quality.

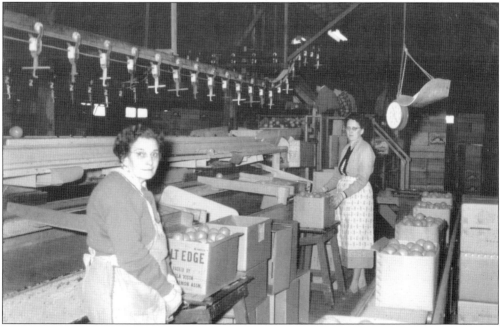

Notice that the Mutual Orange Distributors packing plant in 1956 was no longer packing lemons in wooden crates. As seen here, cardboard boxes were now used to ship lemons. Gilt-edge on the box shows that Mutual Orange Distributors is still using that name to indicate its top-quality lemon.

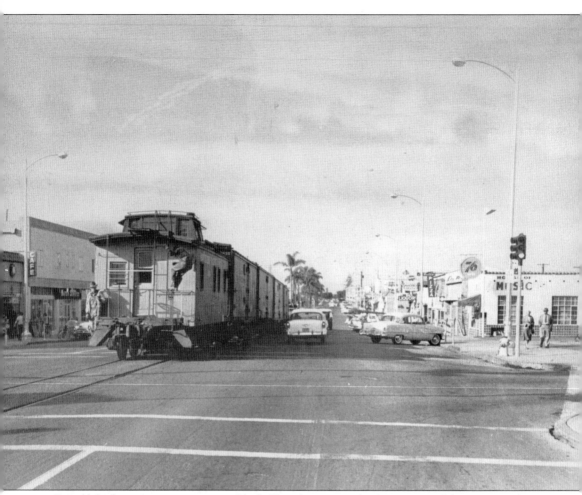

One of the last trains transporting Chula Vista lemons to the far corners of the country, shown from the Sunkist packing plant at K Street, is headed north on Third Avenue past G Street on its way to the main railroad tracks by the San Diego bay. While the Santa Fe Railway was the area's first railroad, the San Diego and Arizona Eastern Railway began operations in 1919. The San Diego and Arizona Eastern Railway was financed and later owned by the Southern Pacific Railway. That explains why after 1920 you see Pacific Fruit Express reefers, a subsidiary of the Southern Pacific and Union Pacific railroads, parked next to Chula Vista packinghouses. It seems clear from this late-1950s photograph that Chula Vista is no longer an agricultural community. And, indeed, both of the last two packing plants closed soon after in 1960, ending the 72-year lemon era that began in 1888. Frank Kimball would have been pleased at its duration. Every August, Chula Vista celebrates a Lemon Festival— although few today understand why. (Courtesy San Diego Historical Society.)

*Three*

# BUILDING A CITY

This road grader is busy in 1913 working on Bay Boulevard. Bay Boulevard was not destined to be an important bay-front road. Rather, from the beginning, William Dickinson had planned for Third Avenue to be the original town center and business street. Center Street, between F and G Streets, has partially been eliminated. The intersection of Third Avenue and Center Street was the center of town until after World War II. Third Avenue is still called "downtown" by most Chula Vista residents. Although its commercial importance has diminished over time, many are hopeful of a rebound as Chula Vista attempts to create an urban core around it. (Courtesy San Diego Historical Society.)

Greg Rogers was one of the original community leaders of Chula Vista at the beginning of the 20th century. Arriving in Chula Vista in 1910, Rogers was elected a city councilman the next year, when Chula Vista incorporated as a city. In 1912, he cofounded and was president of the Peoples State Bank. That bank building still stands on the northwest corner of Third Avenue and F Street.

Greg Rogers is posing with his five children. Originally from Ohio, Rogers, his wife, and their first three children moved from Cleveland to Chula Vista in 1910. In addition to being president of the Peoples State Bank, Rogers also had a lemon orchard and was a member of the Chula Vista Citrus Association (Sunkist). Today Greg Rogers Elementary School and Greg Rogers Park are named in his honor.

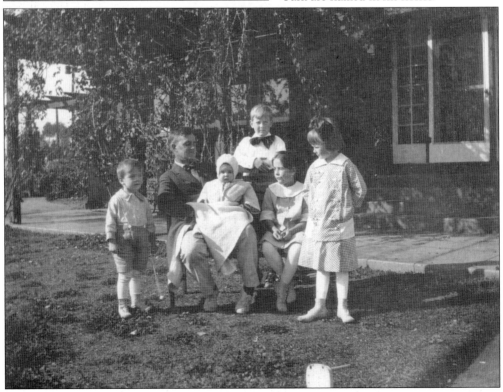

Greg Rogers's home is shown in its original location near the foot of E Street, just west of what is Feaster Elementary School today. Called Bay Breeze, it was aptly named because its location so near the bay resulted in the home having the nicest breeze possible. In 1985, the house was saved from demolition by moving it to Second Avenue.

Edwin Thomas Smith, the man standing in the middle without a hat, was the first mayor of Chula Vista when the city incorporated in 1911. He and a few friends are enjoying some watermelon in front of the Smith home, which still stands at 616 Del Mar Avenue.

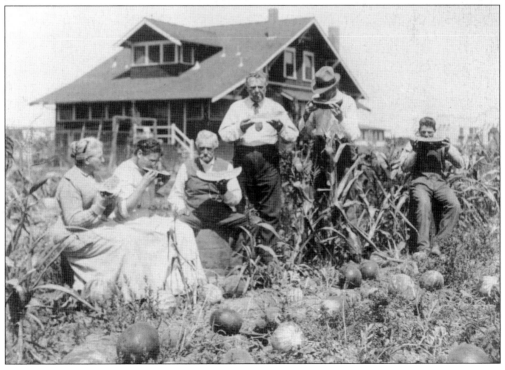

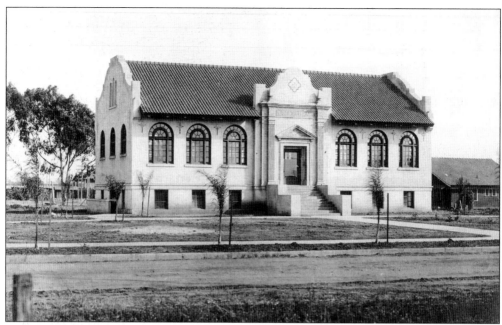

In 1890, some citizens formed the Chula Vista Reading Room Association and were given office space on Third Avenue to house their books. By 1916, the citizens thought it was time to have a proper library, and in 1917, Chula Vista was awarded the money to build the wonderful Carnegie Library. It was located on the corner of Del Mar Avenue and F Street, a site occupied today by the Norman Park Center.

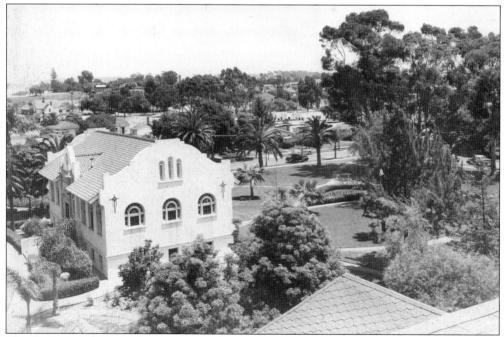

The Carnegie Library is shown several years later when a park, today as beautiful as ever, had been created around it. The Norman Park Center occupies the site today. The photograph has been taken from the tower of the Community Congregational Church next door.

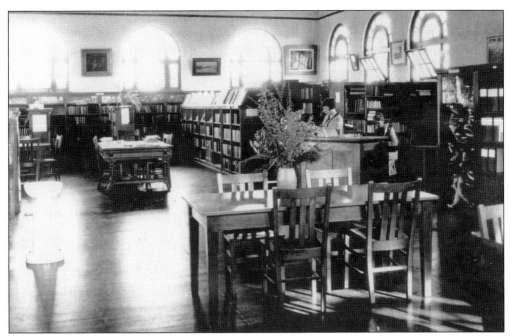

Chula Vista's Carnegie Library, like others of the 1,679 Carnegie Libraries built between 1886 and 1921, was not spacious by today's standards. In California, 142 were built. What a wonderful opening into the greater world it was, especially for small towns like Chula Vista. Of the Carnegie Libraries built in California, 85 still stand, and 36 of those are still being used as libraries. Alas, Chula Vista's Carnegie Library was razed in 1960.

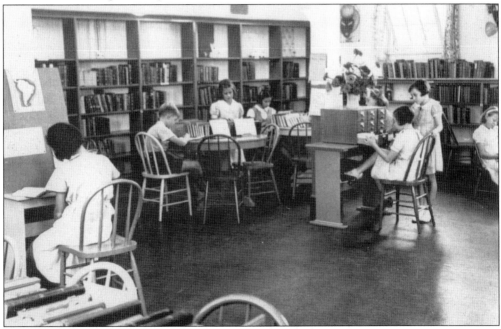

In the pre-television, pre-computer age, the Carnegie Library Children's Room was where many youths received their first knowledge of the wider world around them from books. In small towns particularly, it was a magical place.

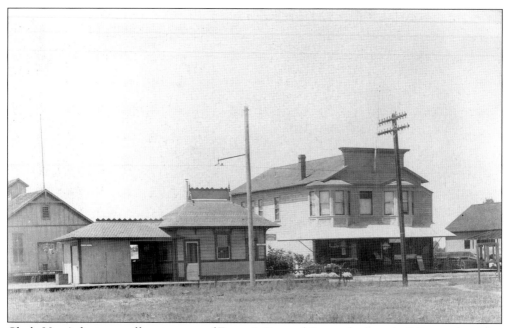

Chula Vista's first post office was part of Farrow's General Store, the large building to the right. The small building in front is the station for the National City and Otay Railroad, which ran down Third Avenue. The station included a waiting room and a ticket office. This photograph is dated about 1905. A few years later, the rail line was electrified for streetcars but continued being used for freight trains as well.

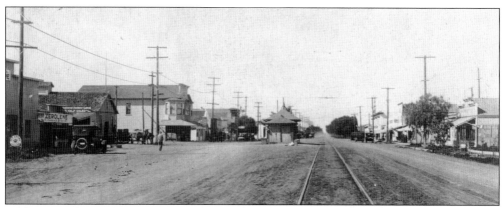

Looking north on Third Avenue, Farrow's General Store (and post office) can be seen to the left, and the railroad ticket office is in the center of the street. This photograph too was probably taken in 1905.

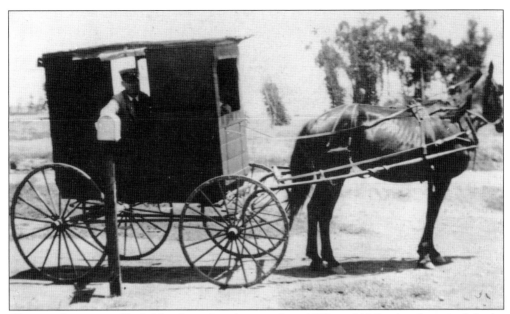

Clarence Austin was Chula Vista's rural mail carrier from 1910 until 1941, when he retired. In the early years, he used a horse-drawn buggy. His predecessor had ridden by horseback, but Clarence preferred a buggy. In the beginning, his route was 18 miles long, and he served 60 boxes. By the time he retired 1941, his route had lengthened to 35 miles, and he carried mail to 1,000 families.

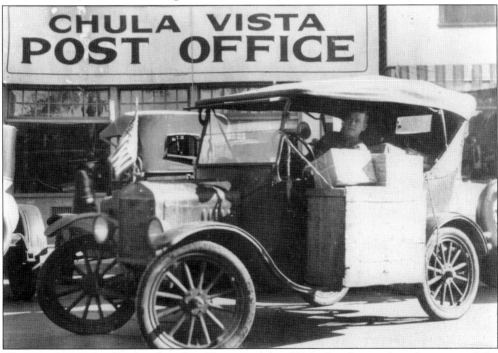

Clarence Austin finally abandoned real horsepower in 1914, when he purchased an automobile. In 1913, the post office had been moved to its own building at 318 Third Avenue. In 1924, when an expansion became necessary, it expanded to include a second building across the street, this building at 315 Third Avenue. This building still exists and now houses a restaurant.

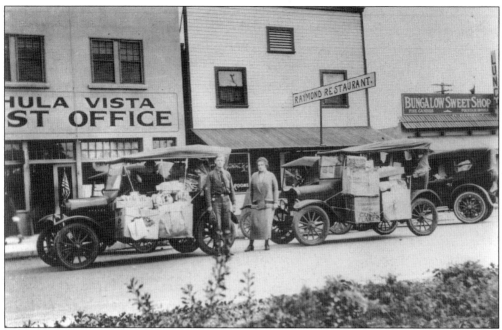

Obviously it is a big mail day at the 315 Third Avenue post office. Clarence Austin in 1924 is about to set off on his route in his Model T Ford. Wishing him good luck is Postmaster Viola Johnson-Uland. In the 1930s, Austin graduated to a Model A Ford. Eventually, a second mail carrier was hired to do the downtown area.

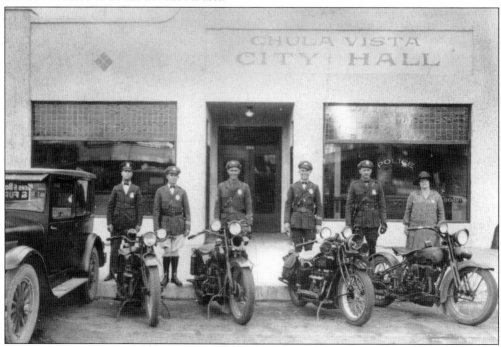

Chula Vista's finest are posing in front of city hall at 292 Third Avenue, just north of F Street. This city hall, built in 1923, housed the city administration, the police station, and the fire station. For a population of about 3,000, they apparently felt the need for a lot of police protection.

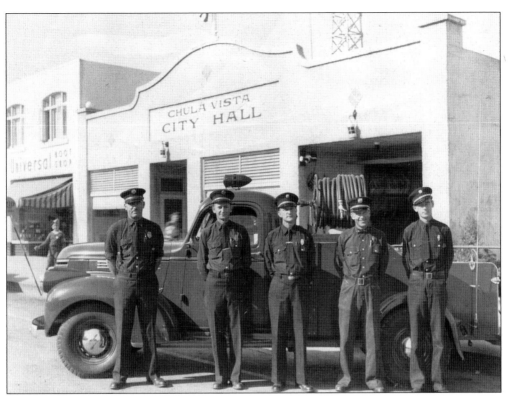

Not to be outdone, several firemen also posed in front of city hall in 1940. This is a 1938 Chevrolet three-quarter-ton truck with a water tank and pump, and it also served as the chief's car. That large opening to the right is where the fire engine would have been parked.

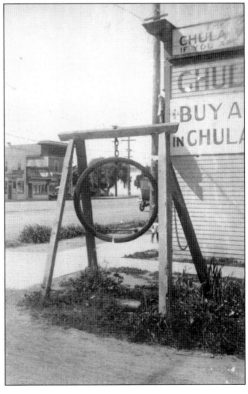

Until 1919, this served as the fire alarm for Chula Vista's volunteer firemen. The alarm was a large iron rim from a railroad wheel that was suspended, and when struck by a sledgehammer, it could be heard a long way off. It was located on the east side of Third Avenue about midway between F and Center Streets. Chula Vista Realty Company certainly seems safe.

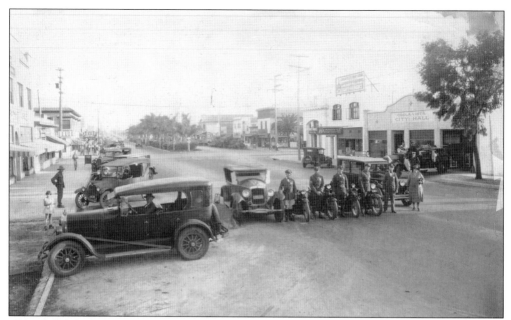

This pose by Chula Vista's police is in a scene looking south on Third Avenue with F Street crossing a few buildings beyond. Note the fire engine parked just outside its garage space in the city hall at the right edge of the photograph. Most of the buildings you see in this 1920s photograph, except those on the far right, still exist.

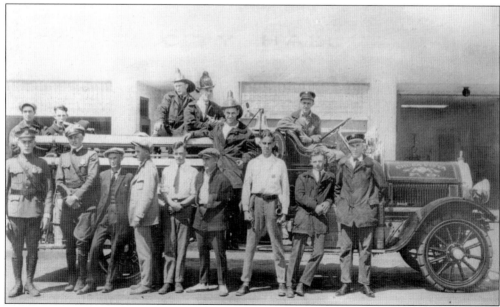

Chula Vista's fire department personnel are posing, in the mid-1920s, in front of city hall. The opening to the right provides inside parking for the fire engine. At this time, most of the firemen were volunteers. The two men in caps to the right are probably the only two paid firemen at the time, one being Chief Charles Smith. The fire engine is a 1916 Seagrave.

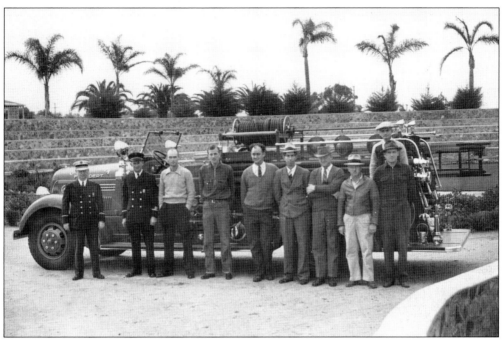

This Seagrave fire engine is parked in Memorial Bowl. Except for the two in uniform, most of the men do not appear to be firemen. In 1941, the city purchased this new Seagrave fire engine, and this may be its arrival.

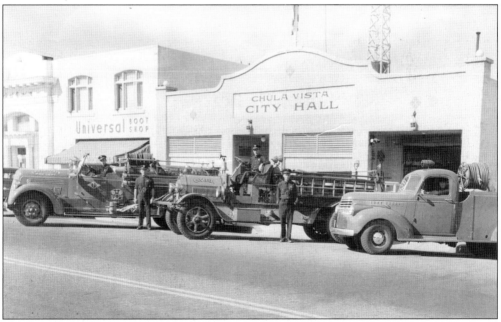

In 1945, the fire department had a 1916 Seagrave pumper, a 1941 Seagrave pumper, and a three-quarter-ton 1938 Chevrolet pickup that could also pump water. Most of the firemen were still volunteers. The 1916 Seagrave would eventually be traded in on a new engine in 1948, then later reacquired in 1968 and restored as the fire department's parade fire engine. The center vehicle has been nicknamed "the Old Goose."

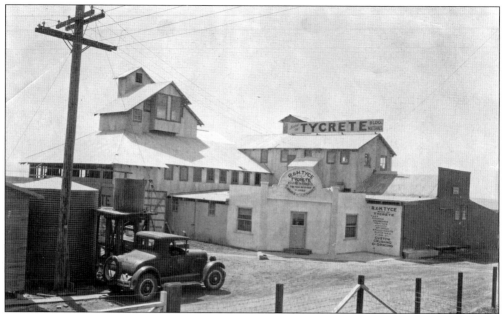

The Tyce family's Tycrete factory, located at the foot of G Street on the bay front, is a space occupied by the Goodrich Aerostructures (Rohr) plant today. Using magnesium extract from the bay, Tyce pioneered in the development of waterproof cement and so produced cement blocks and other cement products. In 1941, Rohr built their factory next to Tycrete and eventually used these buildings.

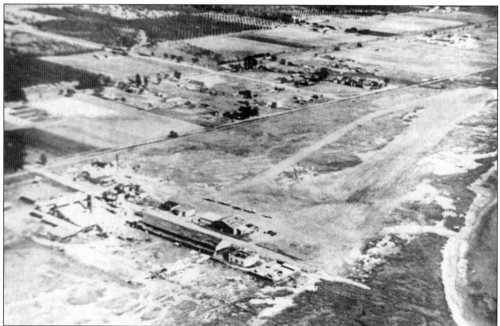

Interested in early aviation, the Tyce family developed the Chula Vista Airport next to their factory. In 1941, Rohr Aircraft built their factory where the dirt runway is in the photograph. Only the Tyce factory buildings in the foreground remained, and in fact, Rohr used one of the Tyce buildings for its first office.

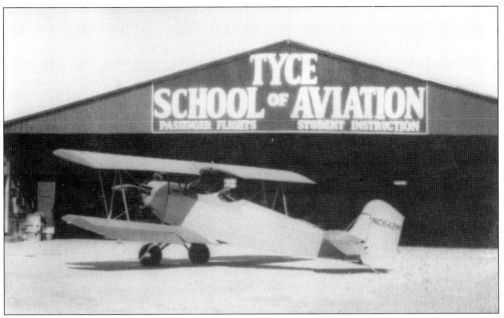

"Tyce School of Aviation," the hanger proudly states. The Tyce family operated this airport from about 1922 until Rohr Aircraft built their factory on the runway in 1941. They gave flying lessons as well as occasionally providing charter service. The plane shown is a Fleet trainer, named for its builder, Reuben H. Fleet, of Consolidated Aircraft Company in Buffalo, New York. Later Fleet moved his Consolidated Aircraft business to San Diego.

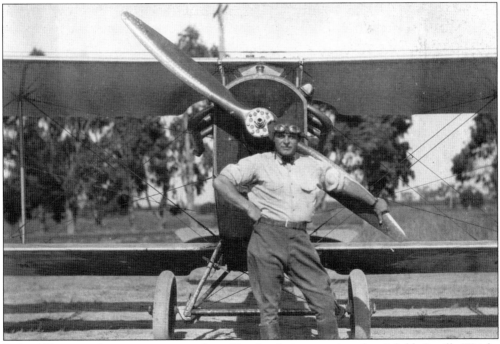

Roland Tyce was the most active member of his family in operating the airfield. Orville Wright signed his aviator's certificate. He is shown here with his World War I Jenny, a Curtiss JN-4D surplus trainer popular with aviation enthusiasts in the 1920s.

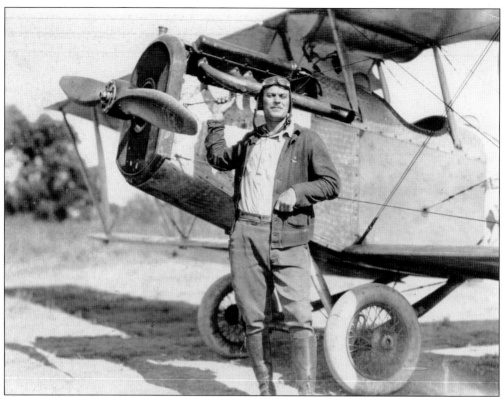

Robert Tyce is posing beside his family's Curtiss JN-4D Jenny. Robert later moved to Honolulu and established an airfield there. Robert was the first civilian killed by the Japanese attack on December 7, 1941.

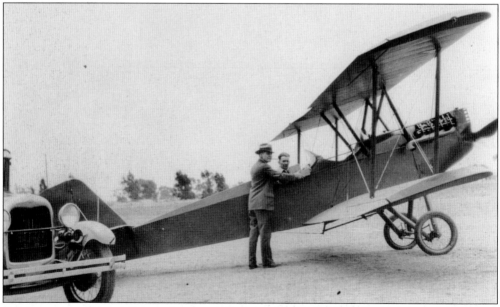

Bob Jacquot is taking delivery of a new airplane at the Chula Vista Airport around 1928. The plane appears to be a Lincoln Eagle with a World War I surplus OX-5 water-cooled V-8 engine.

Hazel Goes Cook moved to Chula Vista in 1912 and established a five-acre lemon grove and home off Pepper Tree Lane. She eventually managed 100 acres of lemons, served as president of the Chula Vista Mutual Lemon Association, and served 50 years on the Chula Vista Elementary School Board. Hazel Goes Cook Elementary School is named in her honor.

The Works Progress Administration (WPA), one of President Roosevelt's make-work programs, built Memorial Bowl during the Great Depression. Originally the bowl had a large water feature as part of it, but the water feature is long gone and a much nicer stage has been built. Memorial Bowl still serves Chula Vista well more than 60 years later.

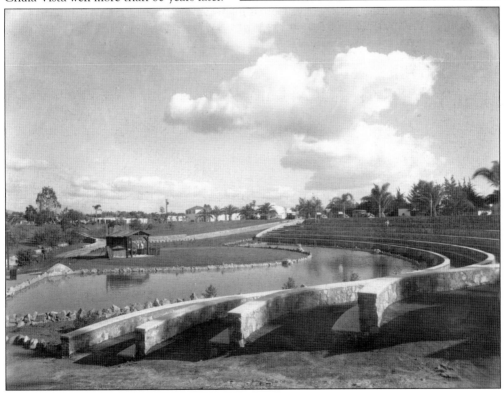

51

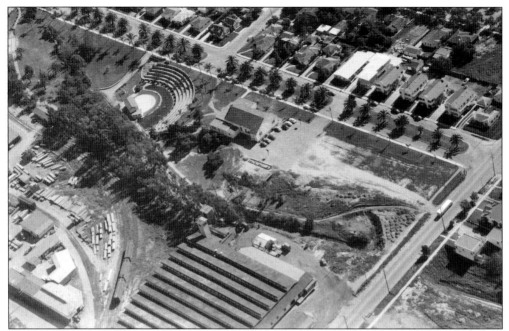

Looking toward the southeast, the street with trees in the median running across the top of the photograph is Park Way. Memorial Bowl is quite distinct near the center top. The building at the bottom with a ridged roof for light is the Mutual Orange Distributors lemon packing plant on Fourth Avenue. The municipal gymnasium was later built just to the south of this plant.

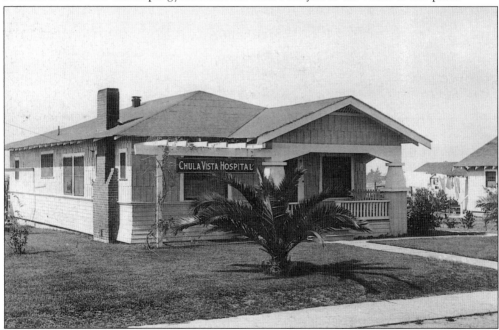

Opening in 1923, the Chula Vista Hospital was located on Third Avenue at I Street and could accommodate only four patients at a time. A. C. Hamman, R.N., was the superintendent of the hospital—and the only full-time employee. The hospital was open to any practicing physician in good standing with a medical association.

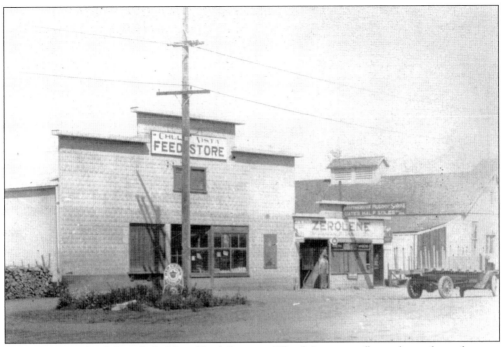

This photograph of the Chula Vista Feed Store on Third Avenue reflects the early, early years of Chula Vista. From its founding in 1888 until World War II, Chula Vista was primarily an agricultural community.

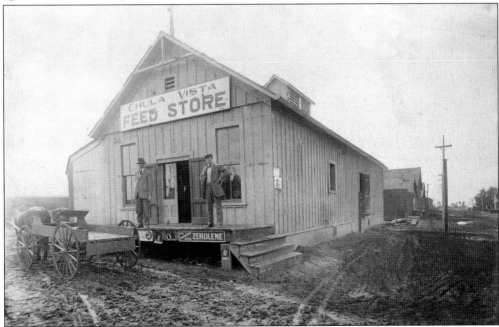

The business end of the Chula Vista Feed Store was the back loading dock. The Sweetwater Dam, completed in 1888, was the first dam in San Diego County, and thus Chula Vista was the first to have a dependable source of water for agriculture. Although lemons were the main crop, they would have handled seeds needed for other crops and feed needed for animals.

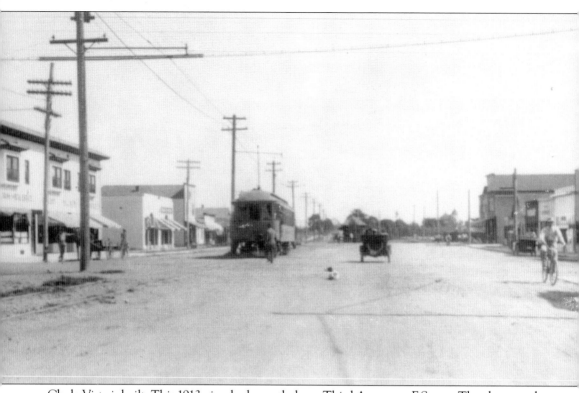

Chula Vista is built. This 1913 view looks south down Third Avenue at F Street. The photograph shows the trolley that came south from National City, across the Sweetwater River, up Second Avenue to E Street, and then over to Third Avenue on its way to the Mexican border. The Melville Building at the left edge of the photograph has been the most recognizable feature of Third Avenue since it was built in 1912, and it remains so today. The 1916 flood washed out the bridge over the Sweetwater River, and the bridge was never replaced. Thereafter, the trolley took the rail lines by the bay and then headed east on F Street to Third Avenue and then south. The tracks can still be seen on F Street between Interstate 5 and Broadway. A grass median with palm trees was then created where you see the trolley, and that median still exists. In the distance, by the tracks, you can see the station.

# *Four*

# EVERYDAY LIFE
## HOMES, SCHOOLS, AND CHURCHES

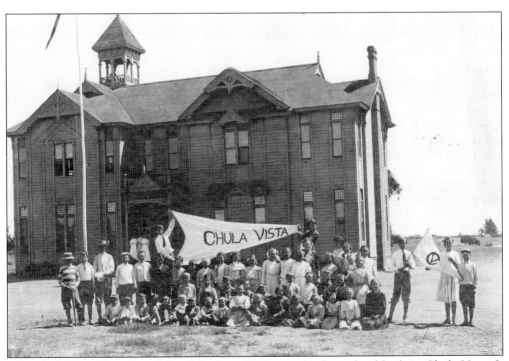

The Chula Vista Grammar School, built in 1890, was the first school built in Chula Vista. It was on the southwest corner of Del Mar Avenue and F Street. For a while, students beyond the eighth grade had to go to high school at Russ High in San Diego. In 1895, the National City High School District was organized, and Chula Vista students went to high school in National City until Chula Vista High School was created in 1947. In 1916, a newer elementary school was built farther west on F Street, and a Carnegie Library was built on this former school site. Then in 1960, the Norman Park Center was built on this property and remains there today.

The Francisco family owned this house at 681 Del Mar Avenue. A daughter, Dema, married William Peters, who owned Peters Feed Store on Third Avenue, an important business for decades. When Dema's parents, Detroit and Mary, became ill, Dema and William Peters moved in to care for them. The house remained in the Peters family until 1971 and is still in its original appearance.

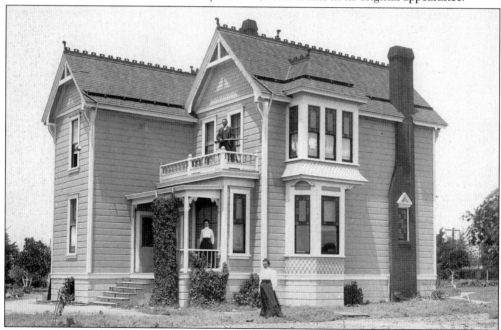

All that is known about this photograph is that it shows the home of the Carter family. It is certainly typical of the houses built in Chula Vista in the late 19th and early 20th centuries with lemon trees in the background. Why is the gentleman holding a rifle? We would love to know! It appears that the roof has an interesting ventilation system.

The Allison Crockett House was built in 1893 and still stands at 320 Second Avenue. As a contractor, Crockett built the Congregational Church on F Street, where the house pictured was originally located. Before the church was built, the house was moved to Second Avenue. Some of the gingerbread is gone, but the basic shape and structure remain the same.

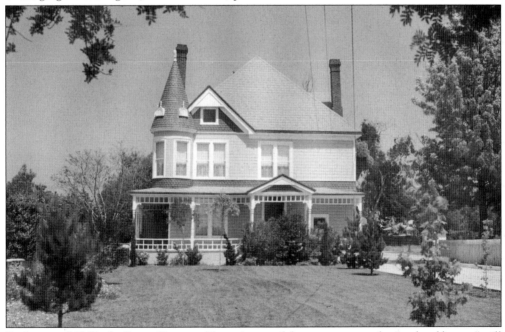

Built around 1888, the Byron Bronson House is one of the most spectacular "orchard homes" still standing in Chula Vista at 613 Second Avenue. The house is an outstanding example of Queen Anne architecture. It is built of California redwood throughout. The original carriage house and horse barn in the rear still stand and have been converted into a small home.

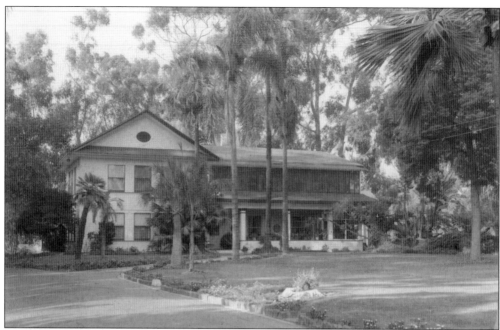

The Augusta Starkey House was built around 1896 and may have been designed by English architect Charles Herman, who lived across the street in the Herman Hotel. The Starkey House still stands at 21 F Street, and the large property still features some of the trees and shrubs brought from around the world by its original owner. The Starkey family owned it from 1932 until about 1990.

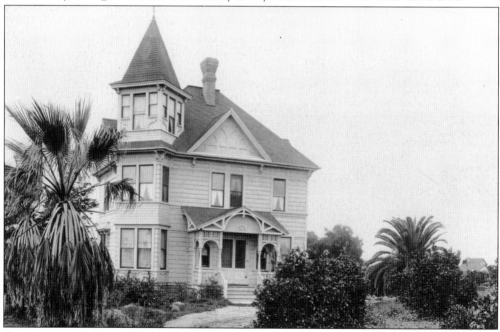

Another spectacular orchard home still standing in Chula Vista is the Cordrey House at 210 Davidson Street. In early photographs taken from the air, its tower, built at a 45-degree angle to the rest of the house, is easy to spot. This view is from Second Avenue; today newer homes have been built in the front yard, so the house fronts on Davidson Street.

Bay Breeze, Greg Rogers's house, is seen under construction (see pages 38–39). Rogers was one of the very early business leaders in Chula Vista, and he built his home near the foot of E Street, overlooking the bay and the ocean.

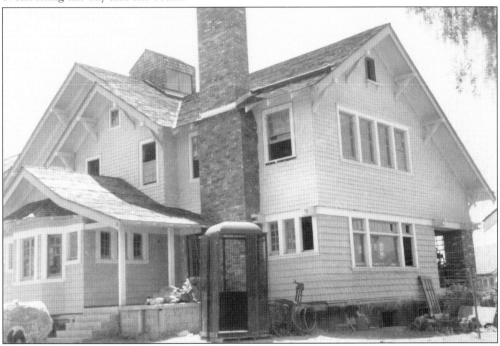

The Greg Rogers's house was originally located near the foot of E Street. Much later, as that area became commercialized, it was necessary to either demolish it or move it. Fortunately, it was possible to move the house to a new location at 616 Second Avenue in 1985 (above), where it has been restored and is a much-valued reminder of Chula Vista's past.

While not one of the oldest houses in Chula Vista, having been built around 1928, the Colonial Revival style of the Leo Christy House at 124 Hilltop Drive certainly makes it unique. Today John Parks and his wife, Nancy, live in the house, and Parks is the third generation of Christys to live in it. It is like a museum inside, except that all the items are actually family possessions kept over the years.

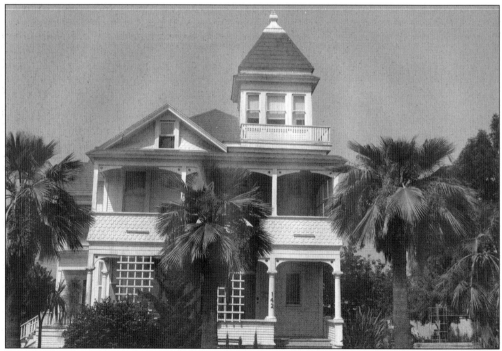

Another of the wonderful old orchard homes still standing is the Edward Gillette House at 44 North Second Avenue. Constructed in 1894, the home was built on a promontory with a commanding view eastward of the Sweetwater Valley below. Nothing has changed. The house is a notable example of Queen Anne architecture.

Built in 1888, the Seaman Haines House at 671 Fourth Avenue was built the year when the San Diego Land and Town Company started selling lots in Chula Vista. In the 1880s and 1890s, when a person purchased a lot in Chula Vista, they had to build a substantial house within two years. That is why so many fine homes, like this one, still stand.

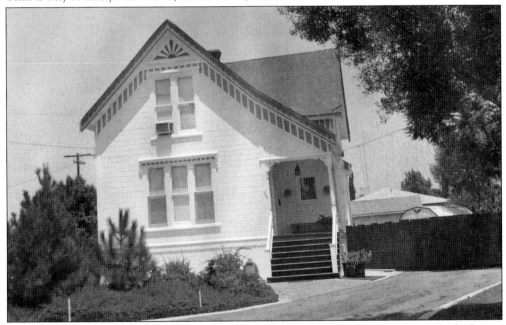

The James Johnson House at 525 F Street was also built in 1888. Johnson not only had a lemon orchard, but he also invented one of the first machines the packinghouses used to wash lemons. Nowadays, the Johnson House is best noted as the house where you can see the back end of Santa Claus as he climbs in that top window at Christmastime.

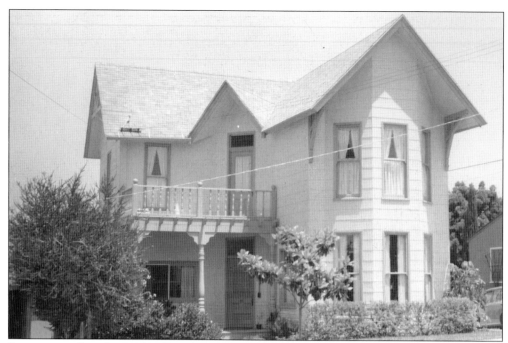

Sometimes referred to as the "Boarding House," indicating a later use, the Maude House at 155 G Street was built in 1889. A lemon orchard originally surrounded the property. Much of the original gingerbread has been removed in this photograph, but the Victorian form still shows through. Recently much of the gingerbread was replaced.

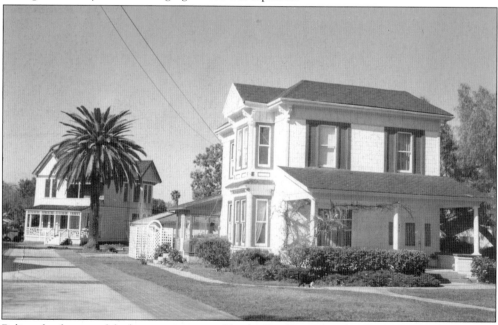

Believed to be one of the houses constructed by the San Diego Land and Town Company in 1888 to begin development of Chula Vista, the Jennie MacDonald House (foreground) still stands at 644 Second Avenue. The house in the rear, 642 Second Avenue, is the Garrettson-Frank House, also built in 1888 but on Third Avenue, and then moved here in 1982 to prevent its demolition.

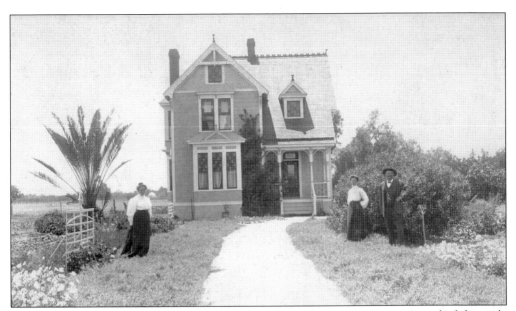

The home of John and Minnie Carter, a house that no longer exists, was typical of the early settlers of Chula Vista. This photograph was probably taken around the dawn of the 20th century. However, the home is old enough to have some landscaping vegetation and small lemon trees in the right background.

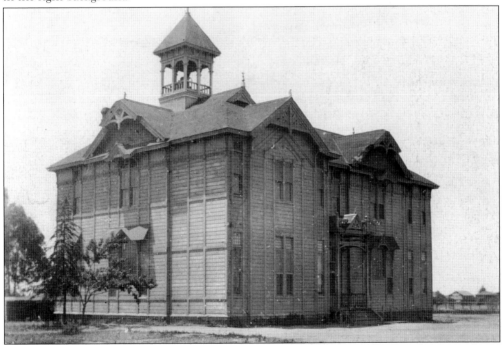

In 1916, a Carnegie Library replaced Chula Vista's first grammar school (above), built in 1890, and the library in turn was replaced by the Norman Park Center in 1960. Note the bell on top. When the school was torn down, the bell went elsewhere, but in 2001, the bell was traced and purchased back and today is on display in the Norman Park Center, the exact site where it began life in 1890.

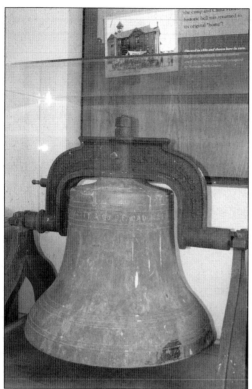

Now on display in the Norman Park Center, this is the 1890 school bell that adorned the top of the Chula Vista Grammar School more than a century ago. San Diego County supervisor Greg Cox, a former mayor of Chula Vista, was responsible for its return. (Courtesy Manny Ramirez.)

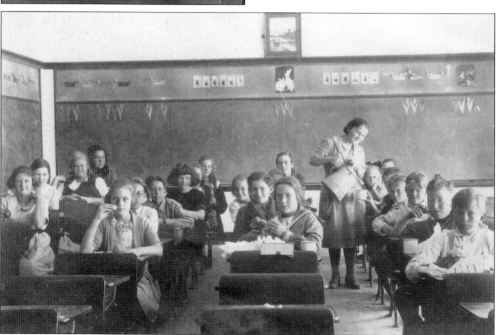

The students appear to be eating lunch in this scene of a classroom in the first Chula Vista Grammar School, taken at the beginning of the 20th century. Perhaps it was a rainy day outside, so lunch had to be eaten inside. If those are drawings of Easter flowers on the blackboard, springtime indeed would be the time for rain in Chula Vista.

A few of Chula Vista Grammar School's students are pictured about 1910; some eighth graders will be going to high school the next year in National City. Chula Vista did not have a high school until 1947.

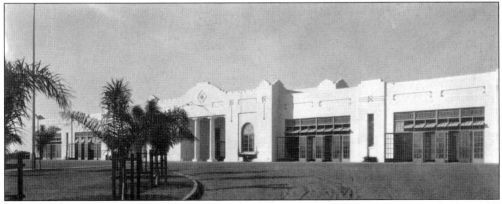

In 1916, a new elementary school was built about three blocks west at F Street and Fourth Avenue. It was always called simply the "F Street School." It served until the 1960s, so many present-day residents attended F Street School. This school was razed, and in 1976, the present Civic Center branch of the Chula Vista Public Library was built on this site as part of America's bicentennial celebration.

A class of second graders are balanced (almost) on the seesaws in front of F Street School in 1919.

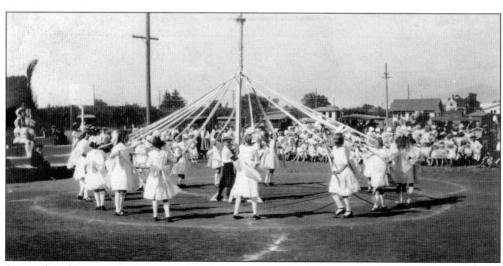

Remember the maypole dances? A centuries-old tradition in Europe to celebrate the beginning of planting season, the dance, usually performed on May 1, used to be popular here in the United States. Here some F Street School children are performing the maypole dance in 1922.

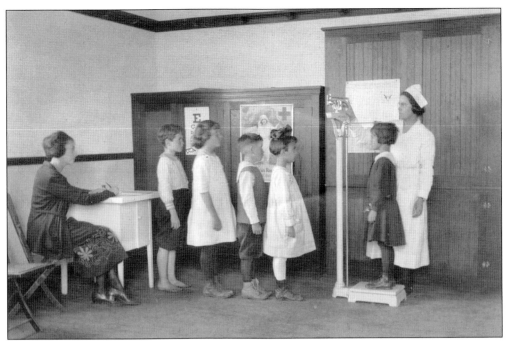

These 1920s children look to be in good health. Big Macs, Nintendo games, and computers had not yet taken their toll by their arrival.

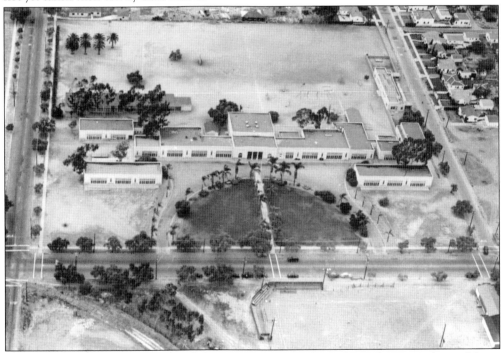

The F Street School is at the corner of F Street (in the center) and Fourth Avenue (up and down the left edge). Today the Civic Center Branch Library is located where you see the school, Will T. Hyde Friendship Park lies on what was the playground behind the school, and the new police station is now on the old ball field seen at the bottom of this photograph.

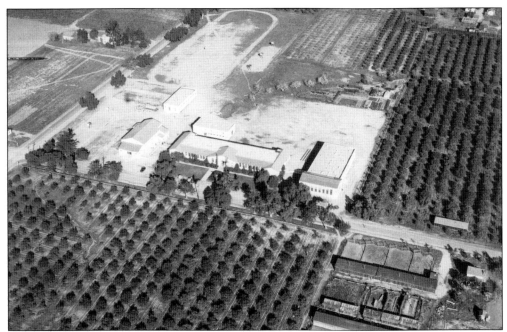

Chula Vista Junior High was built in 1927. Fifth Avenue runs across the front of the school, and G Street is at the left edge of the photograph. Vista Square Elementary School now occupies the lemon orchard at the bottom of the photograph. This school was built during World War II to serve the students from the newly built Vista Square wartime housing project nearby on H Street.

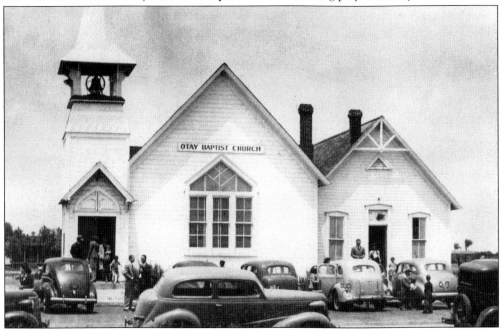

The Otay Baptist Church has been a fixture in the Otay part of Chula Vista since 1890. The original Baptist building is on the right in this photograph. When it became too small, it was moved and attached to a former Methodist church nearby. The bell tower was then switched from the original Baptist building to the larger Methodist building.

The first Catholic church built in Chula Vista was this St. Rose of Lima Chapel built at the corner of Third Avenue and Alvarado Street in 1921. In time, the St. Rose of Lima facilities expanded to include all the property from Alvarado to H Street. Two succeeding church facilities have been built since and, as this is written, plans are in place to completely rebuild the entire church and school facility.

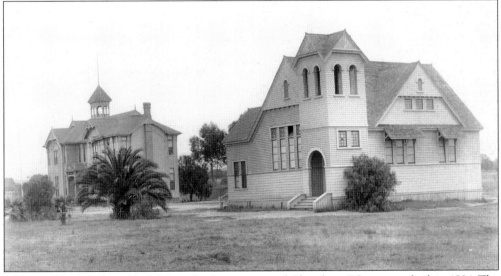

The first church built in Chula Vista, the Congregational Church on F Street, was built in 1894. The church was built four years after the Chula Vista Grammar School, seen in the background.

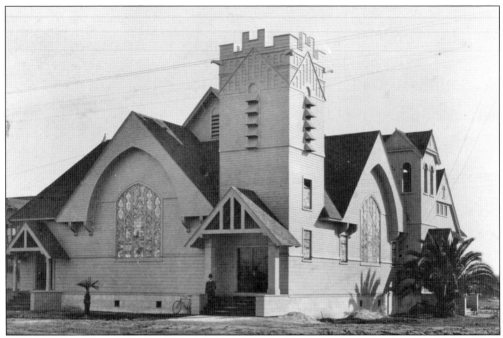

In 1911, the Congregational Church decided to expand their facility. But instead of just adding on to the original church building, they built a church of entirely different architecture. In 1916, when the school next door was razed, the bell in its tower was given to this church, and they installed it in their tower.

In this 1912 photograph, taken from Third Avenue looking east, the Congregational Church can be seen to the left. At the right edge, a new Methodist church is being built at the corner of Church Avenue and Center Street. Today a new Congregational Church built in 1951 sits on the same site as its older church. A Southern Baptist church sits on the site formerly occupied by the Methodist church

*Five*

# THE COMMUNITY AT WORK

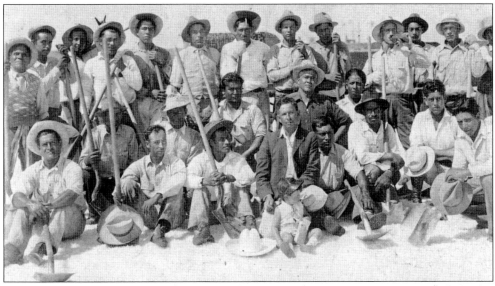

A labor crew is pictured at the Western Salt Works in the late 1920s. The Western Salt Works, founded in 1870, is the oldest continuously operating business in Chula Vista. The first ponds were built to extract salt from the seawater (96.5 percent pure water and 3.5 percent salt) by evaporation. The operation was called the La Punta Salt Company. *La punta* in Spanish means "the point," indicating that the works were at the southern end (or point) of the San Diego Bay. The Spanish had named a major Native American village near here "La Punta," and later Santiago Arguello had a Mexican land grant nearby named Rancho La Punta. In 1902, new ownership named the company the Western Salt Works, and it remained known as such until 1999, when it was sold to the San Diego Airport Authority and renamed the South Bay Salt Works. As this is written, the South Bay Salt Works is nearing the end of its lease. Its future is uncertain. Southern San Francisco Bay had a similar, but larger, operation.

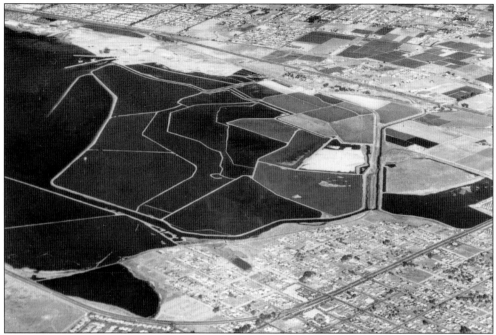

Those white lines are the levees that outline the evaporation ponds in this aerial view of the Western Salt Works at the southern end of San Diego Bay. Seawater is allowed to enter a pond, and the sun slowly evaporates the water, leaving salt behind. The water becomes more salty as it is moved from pond to pond, and the complete process takes about a year.

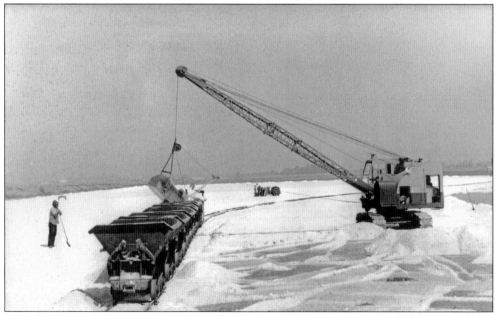

When all the water has evaporated, the salt is harvested by scooping it up and transporting it to the storage piles nearby. Today tractors and trucks do the harvesting. In this old photograph, a dragline crane is scooping up and depositing the salt into these rotary dump cars. The tracks are portable and were moved from pond to pond.

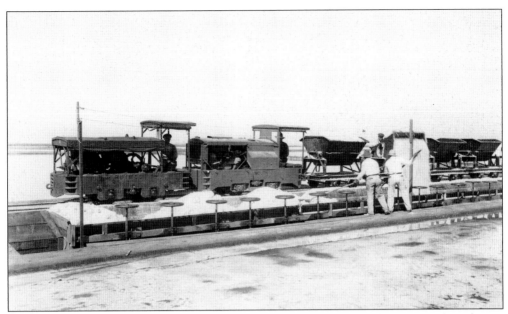

Salt has been brought in on this narrow-gauge train and the rotary dump cars are ready to deposit their salt into the waiting bins. From the bins, the salt will be conveyed to the large, white snow-like mountain. The narrow-gauge tracks were portable and were moved from pond to pond. Today trucks have replaced the train.

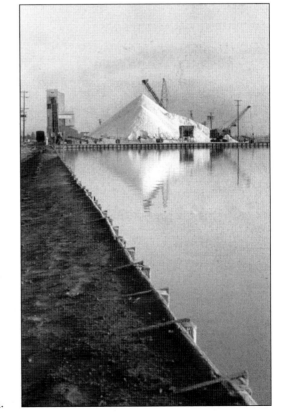

Snow in Chula Vista? Even in color, a passerby could mistake this mountain of salt for snow. The salt is now ready to be carried by conveyor to the shaker tower building for separating into different sizes, then it will be loaded into bags. Originally Western Salt produced a table salt for consumers, but now they only produce salt for industrial uses. At the left edge, a railroad car waiting for its load can be seen.

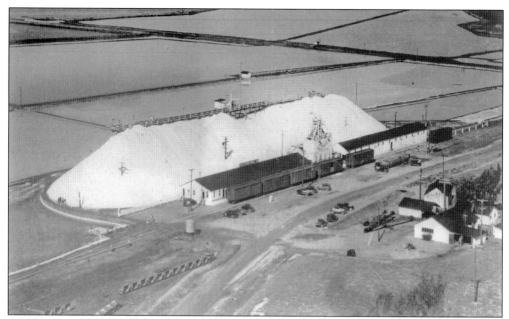

The levees and the ponds can be seen in this overview of the Western Salt operations. The salt is harvested and transported to the snow-like storage piles. After processing, the salt was bagged and transported to the railroad cars shown waiting. Today large trucks are used to haul away the salt instead of railroad cars.

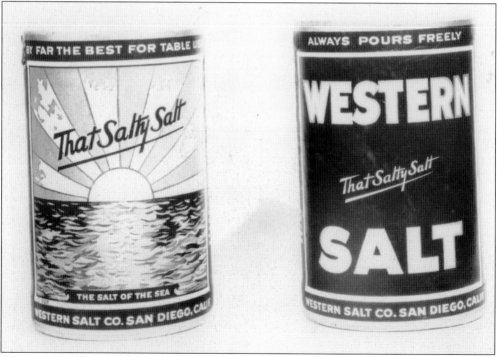

This is a round box of salt produced by Western Salt when they made a table salt for consumers. Their trademark slogan was "That Salty Salt." It would seem one could not ask more of a salt. (Courtesy San Diego Historical Society.)

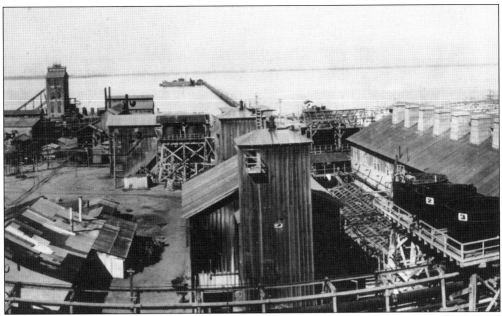

The Hercules Powder Company was a major eastern United States manufacturer of explosives and munitions. Its factories produced black powder and cordite for the American and British armies. Potash and acetone are both ingredients of these powders and can be produced from kelp. Aware that massive kelp beds lay off the San Diego coast, the company, in 1916, built a $7-million kelp processing plant on the Chula Vista bay front. (Courtesy San Diego Historical Society.)

Using self-propelled machines from the largest kelp harvesting fleet in the world, with a cutting mechanism similar to those on grain reapers, they gathered kelp. A cutter a few feet below the water surface cut about two feet off the top of the kelp. The harvesters carried the kelp up an inclined conveyer belt, and then chopped it into small pieces, which were passed onto a barge for delivery to the tank farm.

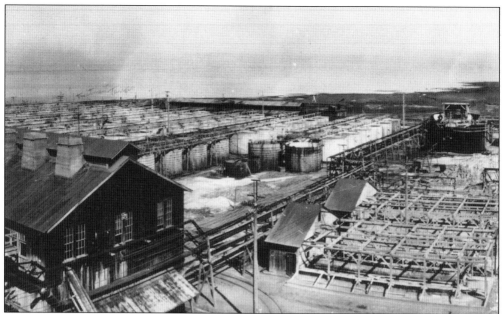

All that remains of this largest tank farm in the world, closed in 1920, are its foundations. These 156 redwood digestive tanks, 15 feet in diameter and 12 feet high, were used in the kelp fermentation process. Fifteen hundred people were employed and worked day and night. Although gunpowder was never produced there, the area, at the mouth of the Sweetwater River, is known as Gunpowder Point. (Courtesy San Diego Historical Society.)

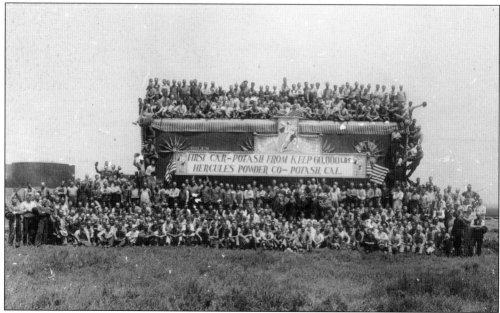

This group of workers conveys the size of the Hercules Powder operation on Chula Vista's bay front. For its day, it was quite a huge operation. A special railroad line was run to the plant, and some of the rails still exist. Although the sign reads "POTASH, CAL.," this scene was in Chula Vista, California. Today the site is designated for a much more benign use, the Chula Vista Nature Center.

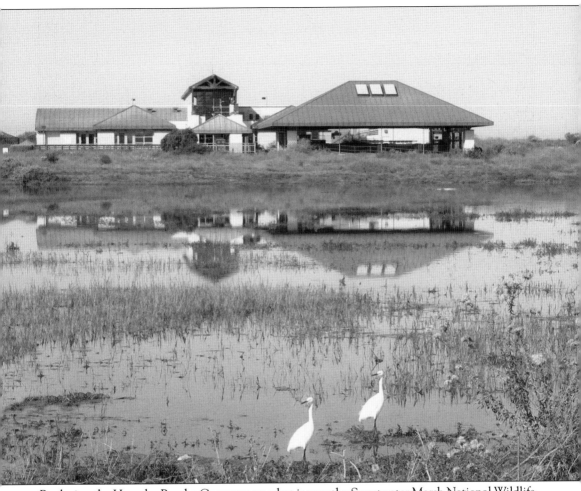

Replacing the Hercules Powder Company on what is now the Sweetwater Marsh National Wildlife Refuge on San Diego Bay is the Chula Vista Nature Center. The center is an internationally recognized zoo and aquarium that exhibits plants and animals native to the San Diego area. One can experience an up-close visit with many natives, such as the endangered green sea turtle, shorebirds, hawks, sharks, stingrays, and jellyfish, to name a few. The nature center opened in 1987 and has since been serving the public with its educational facilities and programs. The center has a paid staff of only 10 people and depends on more than 100 volunteers for its operation. The annual attendance at the center in 2006 was 62,000 people. The 12,000-square-foot center also teaches coastal conservation to an average of three to four 40-child school groups each day during the traditional school year. (Courtesy Chula Vista Nature Center.)

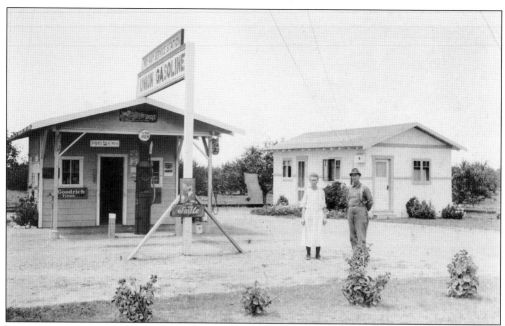

Mid-Way, a very early service station, was probably on National Avenue (now called Broadway). Union gasoline is still around. Note the advertisement for Goodrich Tires. Who could have guessed that decades later, Goodrich would get out of the tire-making business and would be building aircraft parts as Goodrich Aerostructures just a few blocks away after buying Rohr, Inc.

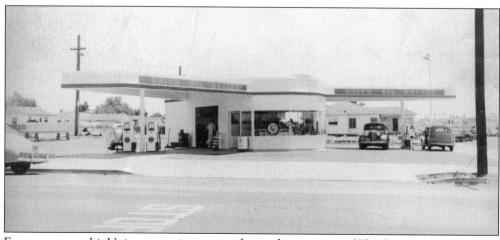

For many years, this Union gas station was on the southeast corner of Third Avenue and E Street. Both of the authors used to pump their kids' bicycle tires at this station. The view looks south across E Street.

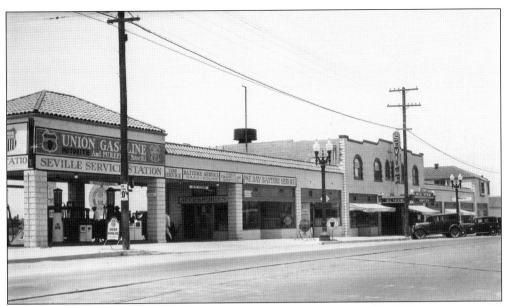

In a view looking north, this Union station was on the northwest corner of Third Avenue and G Street. The Seville Theater is north of the station, and the Seville Service Station got its name from that connection. Norbert Stein's Butcher of Seville shop was a few doors beyond.

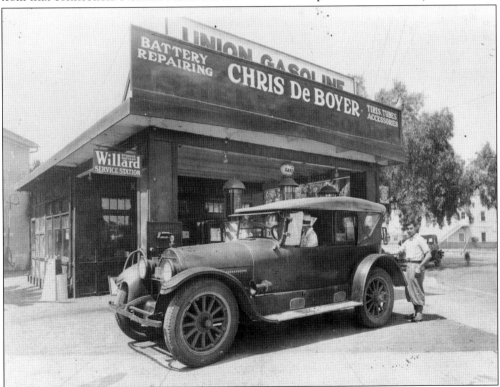

Chris DeBoyer's service station on the southwest corner of Third Avenue and F Street was also a Union station. By the look of this car, the photograph must have been taken about 1920. The attendant seems to have knickers on.

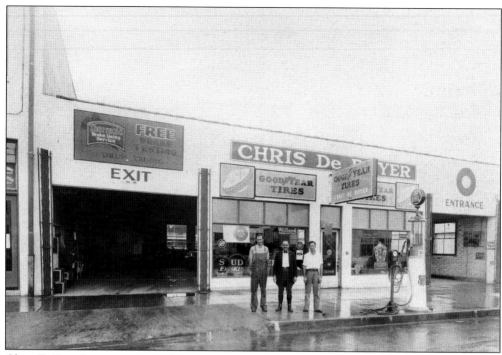

Chris DeBoyer's service station has certainly been improved and modernized, and it has added some services. However, the station was still pumping Union gasoline for its customers.

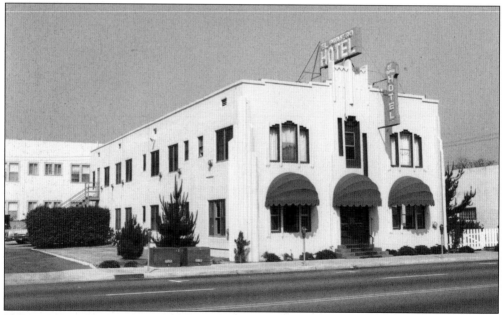

El Primero Hotel was the first modern hotel in Chula Vista and is a rare example of zig zag moderne architectural style. Built in 1930, the hotel was said to be fireproof, was carpeted throughout, and was complete with steam heat and hot and cold running water. It is Chula Vista's oldest hotel. It gradually declined over the decades, but in recent years, Pie Roque has restored the hotel to its original magnificence.

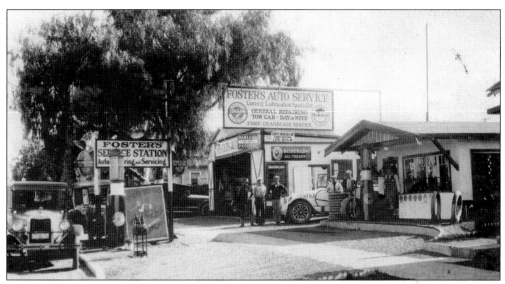

Foster's Auto Service station was located on Third Avenue at E Street. Do you remember Red Crown Gasoline? How about Seiberling All-Tread Tires? Maybe you drove an Oakland automobile? They could fix it here for you. If you needed "Correct Lubrication," they offered a choice of Zerolene or Mobiloil. Now there is a name we can recognize! This photograph was probably taken in the 1920s.

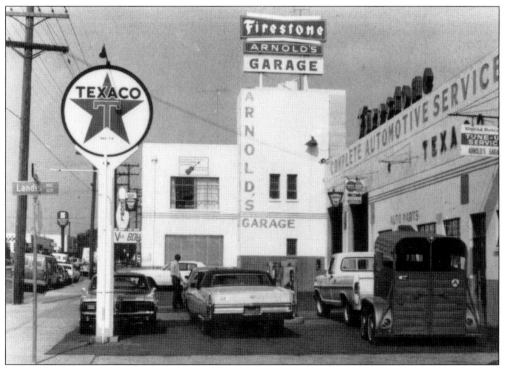

Arnold's Garage on F Street just west of Third Avenue was a familiar sight for several decades. Zach Arnold had his previous garage on the southeast corner of Third Avenue and Madrona Street. In 1946, he moved to this location and operated here until a redevelopment project took the property in 1980. The site is now a Marie Callender's restaurant.

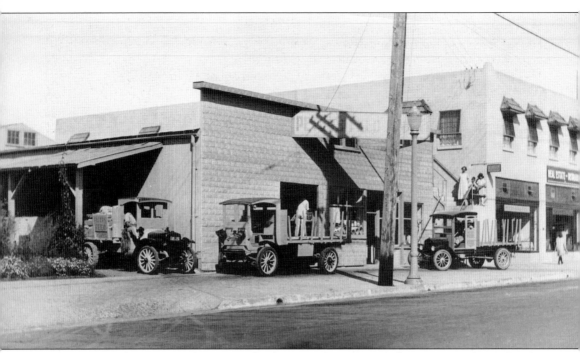

The Peters Feed Store was a fixture on Third Avenue from 1924 until 1980. Located near Center Street, it was one of the most important businesses for a community that was largely agricultural until 1940. William Peters sold grains, seeds, hay, poultry supplies, fertilizers, insecticides, and garden tools. By the appearance of these trucks, this photograph must have been taken in the 1920s. As the demand for animal feed dwindled after World War II, Peters turned his business more and more into a nursery, and its name evolved into Peters Home and Garden Center. William Peters lived in the wonderful Francisco house at 681 Del Mar Avenue, shown on page 56. When the business was forced to move to a new location in 1980, its then owner, Joan Klindt, continued Peters Home and Garden Center much farther north on Third Avenue. She and Peters Home and Garden Center retired in 1993, ending 70 years of service to Chula Vista.

The Chula Vista Paint Store was in business for many years on Third Avenue, two doors north of F Street. That is the Peoples/Bank of America building at the left edge of the photograph, and the building that housed city hall, the police station, and the fire station is at the right edge. The building is little changed today.

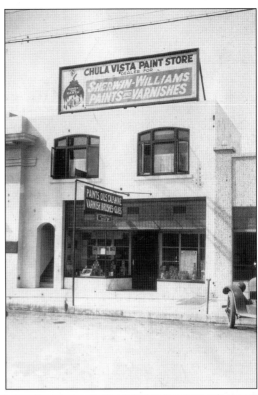

Henry Grant Rising is standing in front of the *Chula Vista Review* offices on Third Avenue. Rising started the newspaper in 1911, and it was the first newspaper in Chula Vista. This paper was published from 1911 until 1918. Sad to say, except for the first issue of this newspaper, all copies of later editions have been lost and with them much of the early history of Chula Vista.

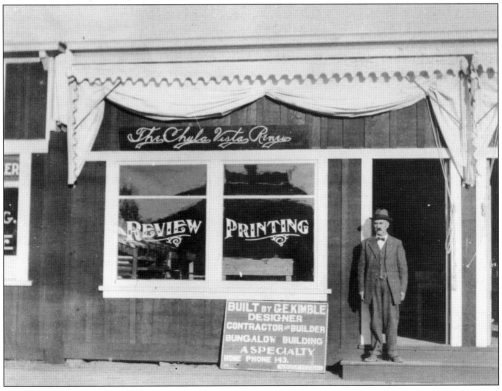

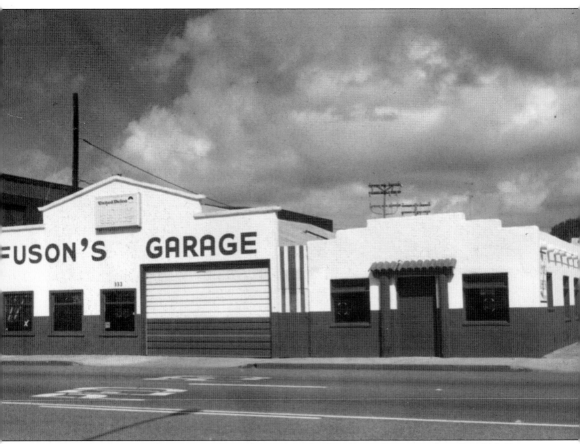

Fuson's Garage was a fixture on F Street for six decades. Rex Fuson began working for Herb Bryant in 1921. Bryant specialized in fixing electric automobiles and radios in his shop at 333 F Street, just west of Third Avenue. More interested in radios, Bryant sold the automobile business to Fuson in 1922, and Fuson's Garage was thereafter operated by three generations of Fusons. During the late 1920s and early 1930s, most of the work at the shop was servicing lemon orchard trucks, tractors, and related farm equipment. One customer had bought a new 1940 DeSoto, and Fuson's had the privilege of servicing it for 32 years before it was retired. The adobe building on the right, which at the time of the photograph was the Fuson's Garage parts department, was originally the home of the *Star*, the second Chula Vista newspaper that was started in 1919. Later the *Star* merged with the *National City News* to create the *Chula Vista Star-News* read today.

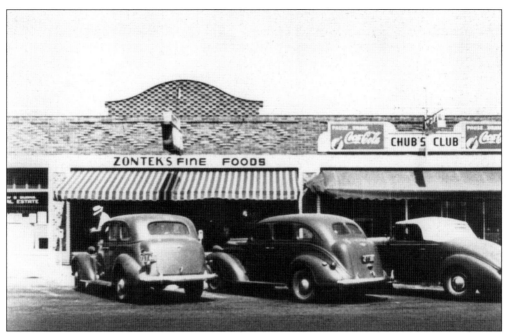

In 1940, three Zontek brothers opened the Zontek's Fine Foods restaurant at 273 Third Avenue and operated successfully there for 12 years. The brothers came to Chula Vista from Minnesota. In 1953, the brothers split up, one starting another business nearby and the other two opening a new Zontek's restaurant elsewhere on Third Avenue.

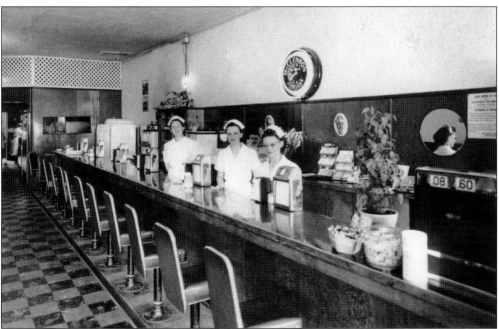

Inside Zontek's original restaurant, that cash register never saw a transistor or computer chip. The clock on the wall advertises McClendon Jewelers, which was a store across the street. McClendon Jewelers is still across the street 67 years later, although Jack McClendon has long since passed on.

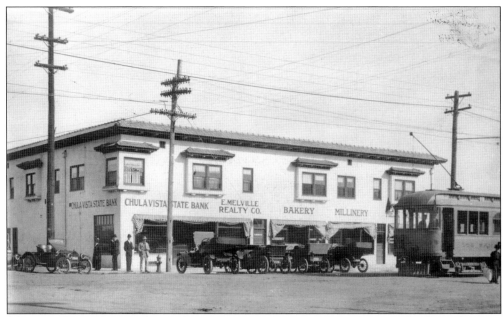

The Melville Building on the southeast corner of Third Avenue and F Street has been the most continuously familiar sight on Third Avenue for generations of Chula Vistans. It was built in 1911. The streetcar indicates that this photograph was taken before 1916 when its tracks over the Sweetwater River were washed out by flood. Note the E. Melville Realty Company sign.

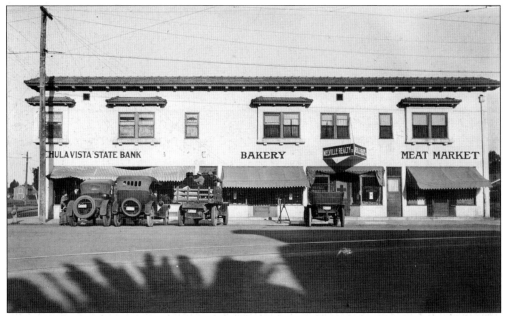

Edward Melville was one of the pioneer businessmen in Chula Vista. Note the Chula Vista State Bank, which operated from 1911 to 1918. The absence of supports on the telephone poles for trolley wires indicates that this image was taken after 1916, when the streetcar no longer ran on this section of Third Avenue. The sign extending out from the wall, between the bakery and the meat market, reads "Melville Realty."

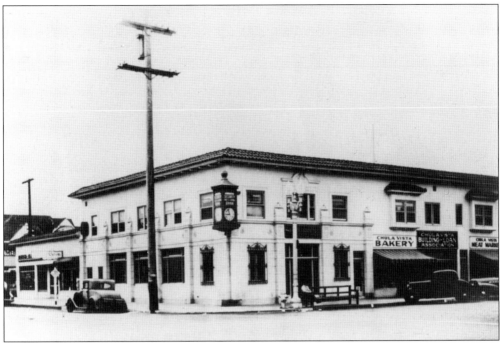

The Security Trust and Savings Bank, in the corner office of this 1930s view of the Melville Building, operated here from 1929 to 1953. Edward Melville's descendants still live in Chula Vista.

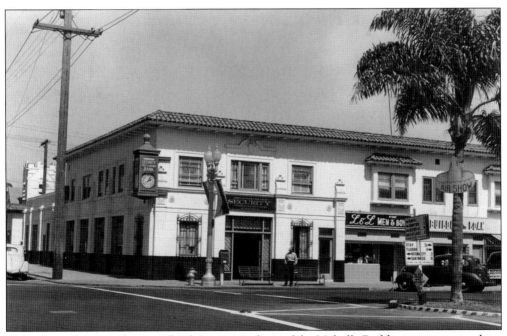

The grass and tree median on Third Avenue, in front of the Melville Building, now covers where the streetcar tracks used to be. Also note the small mailbox on the corner—big enough for a small population. The building is little changed today, although some of the ornamental features have been stripped from this formerly elegant business building.

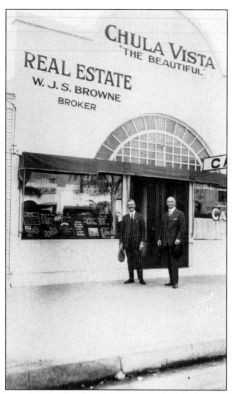

"Chula Vista the Beautiful" was a good slogan for a real estate broker in Chula Vista. W. J. S. Browne (right) was a prominent businessman in Chula Vista for many years and was usually referred to as "Alphabet" Browne. Huley Phelps, one of his agents, stands on the left. The office was at 318 Third Avenue, which was originally a post office.

Dock's Cocktail Lounge has been a fixture on Third Avenue since before World War II. The sign looks exactly the same today and probably is the same sign. The front window, however, no longer has this 1930s moderne look. The Rexall Drug Store down the way was a popular drugstore chain of the time.

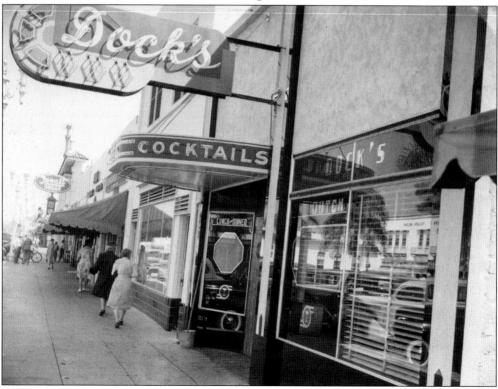

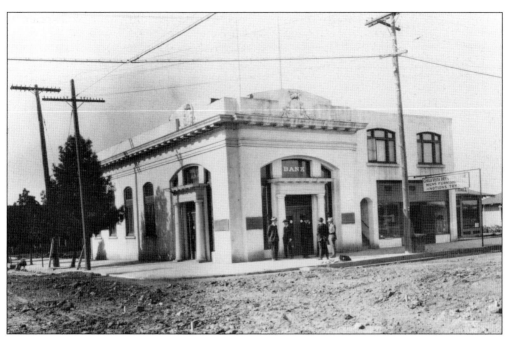

The Peoples State Bank was built in 1911 at the northwest corner of Third Avenue and F Street. Later it became a Bank of America. Since the Bank of America moved in 1948, the building has been used for a variety of businesses. In 1998, a business decided to put in a skylight and found they had to cut through some 12 inches of concrete in the ceiling—the top of the old vault!

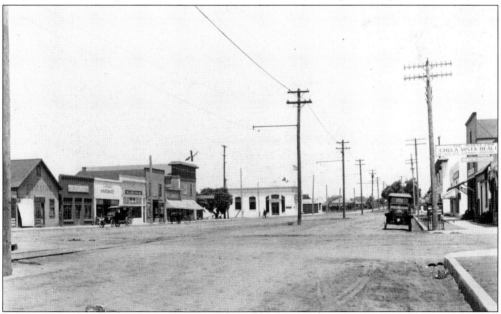

The Peoples State Bank can be seen in the center distance in this view looking north on Third Avenue from Center Street. This photograph was taken about 1912 soon after it was built. The streetcar tracks still are down the center of Third Avenue, as they were until after the 1916 flood. Note the automobile parked on the other side of the street and a horse and buggy parked close behind.

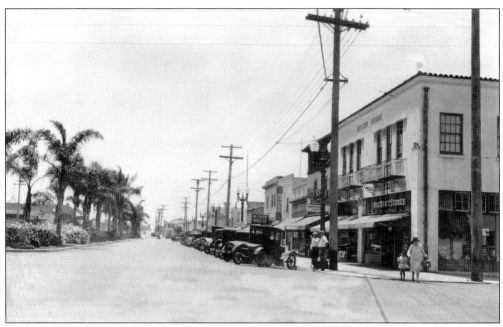

The vintage of these cars indicates the photograph was taken in the 1920s. At the left, the mature growth in the median that replaced the streetcar tracks after the 1916 flood is seen. All the buildings on the right side of the photograph (west side of Third Avenue) were demolished in a redevelopment project of 1980.

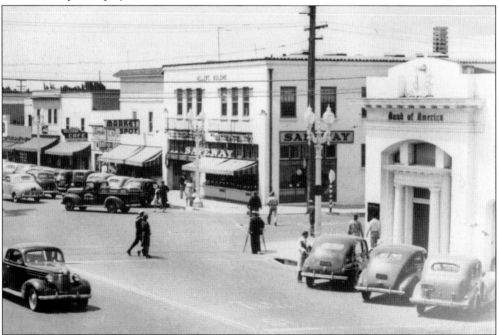

Similar to the above photograph, but taken in 1936, the Bank of America building to the right was built in 1910 as Peoples State Bank and is still standing, but it is no longer used as a bank. Since the Bank of America moved out in 1948, the building has served as a women's dress shop, as a restaurant, and more lately as a Christian Science Reading Room.

The cameraman took this photograph looking northwest across Third Avenue from F Street in 1908. The original Third Avenue streetcar tracks are running diagonally across the bottom of the page toward E Street to the right. From there, the tracks turned east to what is now Second Avenue and then north on Second Avenue to National City. Several hundred young lemon trees are in view.

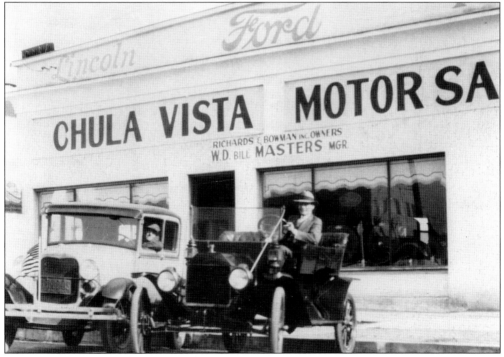

Chula Vista Motors was located on F Street just west of Third Avenue. In this photograph, they seem to be contrasting a Model T Ford (on the right) with a Model A Ford. It is believed they were trying to show that everything was up-to-date in Chula Vista.

Taken from the Congregational Church tower on F Street, this photograph looks southwest across Third Avenue. The palm trees in the median of Third Avenue can be seen in the center. The building in the left center of the photograph, just beyond all those cars, is on Center Street. The side of that building now displays a wonderful mural honoring the area's lemon history. Center Street is also where the farmers' market is held in 2008.

Perhaps taken at the same time as the above photograph, this view looks directly west down F Street toward the bay. To the right is the Bank of America building shown on the previous page, and a block beyond is Fuson's Garage described on page 84. The two-story building right in front of the camera location is the back of the Melville Building described on pages 86 and 87.

The *c.* 1911 construction of the Melville Building is seen at the right edge of this view looking east across Third Avenue. The original Congregational Church stands beyond Karl Helm's automobile repair garage. Notice the horse and buggy in front of the automobile repair shop. That says something about the dependability of the early automobiles.

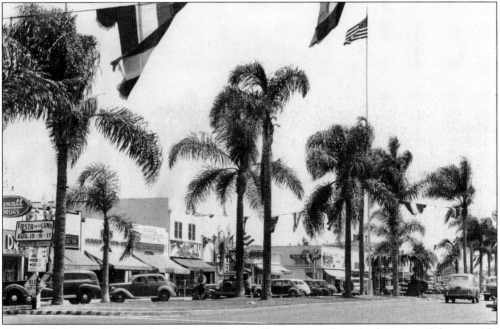

Almost all the buildings in this photograph are still as you see them in this view of the east side of Third Avenue just before World War II. All of the buildings on the west side of Third Avenue, just out of view to the right, were demolished for redevelopment in 1980. The two-story building seen just left of center was the post office in the 1924 photograph on page 44.

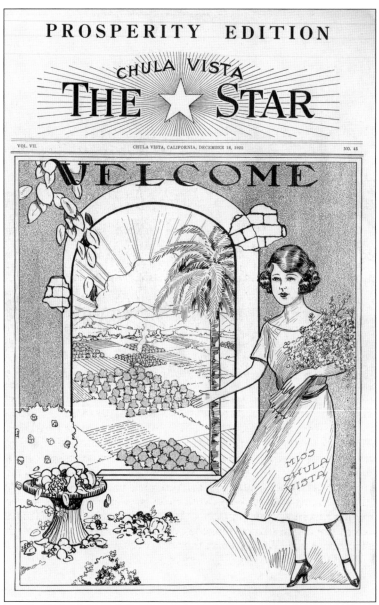

The December 18, 1925, edition of the *Star* was a special edition labeled the "Prosperity Edition." It was 15 pages stating everything one could imagine good in Chula. On page 15, the edition gave quite a list of "Figures Show[ing] Its Substantial Growth." Some of the more interesting ones include "Population in 1925, 4,500; Newly Paved Streets, 7 miles; Lemon Shipments, 781 [railroad] cars; Celery Shipments, 450 cars; Fresh Tomatoes, 100 cars; Cauliflower, 80 cars; Lettuce, 25 cars." Truck farming and row crops were becoming more and more important. Page 15 also summarized the paper's view of Chula Vista: "Chula Vista is now on the eve of one of the greatest industrial, agricultural and residential developments ever known in its history. Year after year our fertile fields and orchards yield food stuffs for the multitudes. Chula Vista, in the center of this realm of endless productivity, grounds her prosperity on the surrounding wealth of agricultural resource, and, as well, upon her pre-eminence as a center of industry and trade." The front page shown certainly reflects this view.

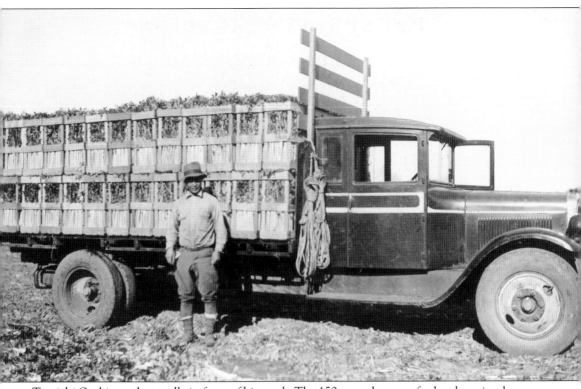

Toraichi Ozaki stands proudly in front of his truck. The 150-pound crates of celery have just been harvested and are on their way to markets around the country. Japanese men first immigrated to this area in the early 20th century because of difficult economic times in Japan. When it became clear that they were not going to return to Japan, wives were recruited one way or another, often by exchanging photographs. The women became known as "picture brides," an expedient that was also used by many Americans as America moved west. Eventually many Japanese wanted their own farms, but the United States and California had enacted several very discriminatory laws against them. Finding ways to coexist with these laws, many Japanese farmers established successful farms in California, including Chula Vista. The Japanese were excellent truck farmers, growing row crops like celery, lettuce, tomatoes, cucumbers, peppers, and so forth. Celery was particularly important, and by 1940, revenues from celery equaled lemon revenues in Chula Vista. (Courtesy Japanese American Historical Society of San Diego.)

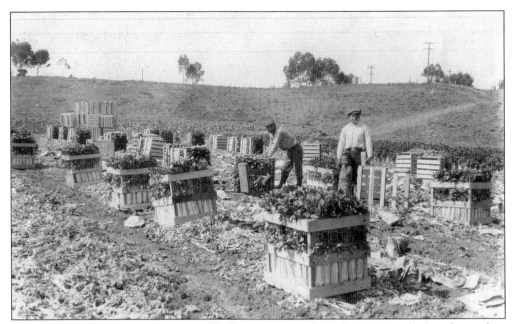

Two of the many Japanese farmers in Chula Vista are packing their crates of celery for market. There were more people of Japanese descent in Chula Vista before World War II than anywhere else in San Diego County. They were early experimenters with drip irrigations and developed a technique of growing tomatoes on poles, thereby achieving a greater yield per acre. (Courtesy Japanese American Historical Society of San Diego.)

This is an example of a fruit crate label used by a Japanese farmer in Chula Vista. Another Japanese farmer, Toshiaki Hasegawa, helped to pioneer in the use of drip irrigation. Drip irrigation was found to be particularly useful for watering pole tomatoes, an innovation that had initially been introduced in the 1930s by Japanese farmers in Chula Vista. (Courtesy James M. Yamate.)

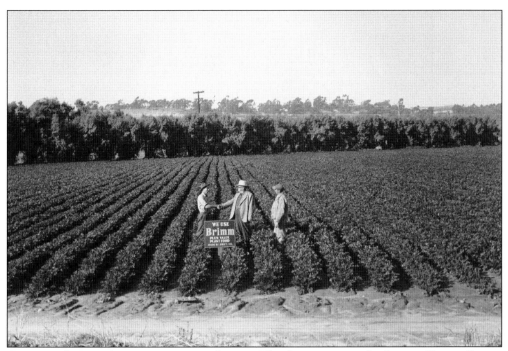

Caucasian farmers also grew row crops, of course. This farmer seems to be doing well using Brimm Plus Value plant food. It would appear that a Brimm salesman is congratulating the farmer. While the last lemon packing plants closed in 1960, truck farming continued for many years.

Ray Koenig stands amid what looks to be a good crop of beans. Koenig had an eight-acre farm in the Sunnyside area, and in this particular year, at least, his farm managed to produce an outstanding crop.

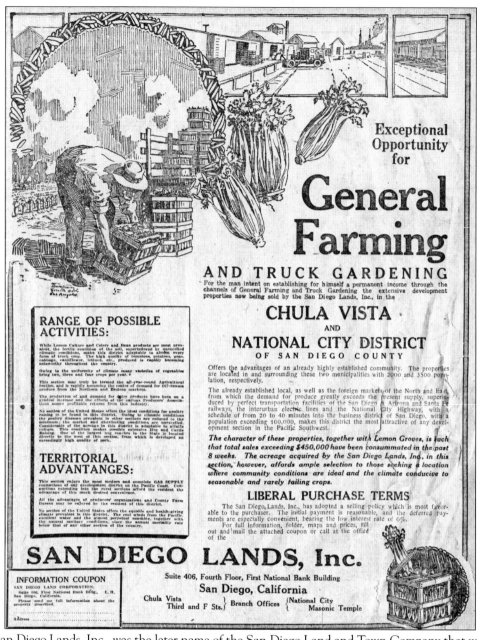

San Diego Lands, Inc., was the later name of the San Diego Land and Town Company that was created by the Santa Fe Railway in 1888 to develop Chula Vista. The company finally worked itself out of business in 1923. This is an advertisement the company placed in the *Los Angeles Evening Herald* on March 27, 1920. In print too small to read here, the advertisement says "For the man intent on establishing for himself a permanent income through the channels of General Farming and Truck Gardening the extensive development properties now being sold by the San Diego Lands, Inc., in the Chula Vista and National City District of San Diego County offers the advantages of an already highly established community." Even on this reproduction, the importance of the celery crop is indicated. At the top and at the bottom of the advertisement, crates of picked celery on its way to far-flung markets can be seen.

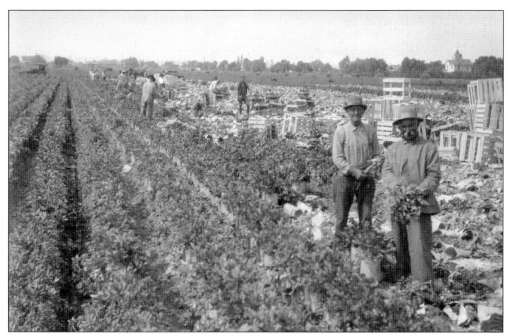

The Japanese developed winter celery that, because of Chula Vista's climate, could be grown year-round and shipped as needed. By 1940, celery was the largest revenue-earner of Chula Vista's agricultural community, surpassing even lemons.

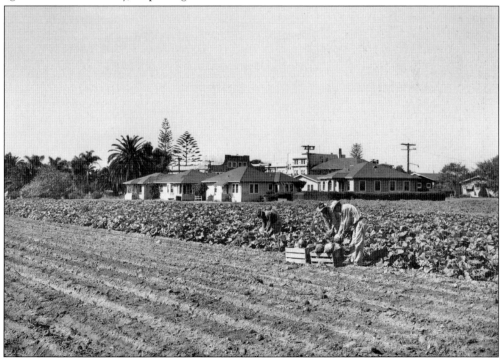

Houses are beginning to encroach more and more on Chula Vista's vegetable fields and lemon groves, as demonstrated by these postwar workers picking melons or gourds. By 1980, most traces of Chula Vista's agricultural past had disappeared.

Vener Farms, owned by Sam Vener, was the last major truck farm in Chula Vista. The tomato, lettuce, and cucumber fields were on the bay front at the foot of E Street. This view looks south toward the Rohr plant. The foundation of his packing shed still exists southwest of the gate to the nature center.

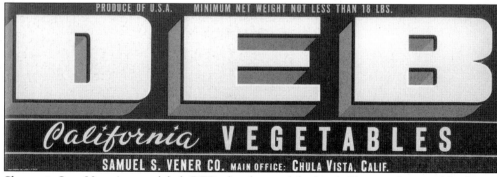

Shown is Sam Vener's crate label, DEB, that he used for his field cucumbers and hothouse cucumbers. In this case, the inspiration for the crate label name came from his daughter, Deborah. (Courtesy Louis E. Vener.)

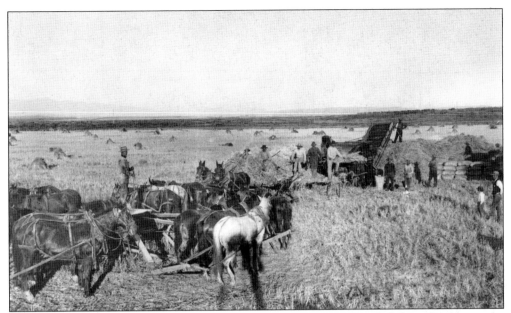

The Sweetwater Dam was completed in 1888. The water flowed downhill from the dam to the lemon groves and vegetables fields in what is now western Chula Vista. But water could not be pumped in those early days, so eastern Chula Vista was characterized by dry farming, such as alfalfa, barley, wheat, oats, and lima beans. Here barley is being threshed.

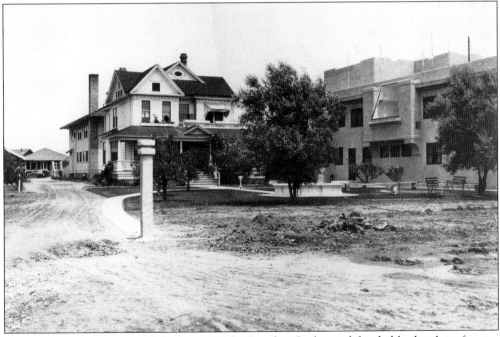

Frederika Manor was established in 1908 by Roselyn Saylor and funded by her benefactors, Frederika and Henry Timken of the Timken Roller Bearing Company. It was one of the first retirement homes to consist of cottages and multi-story facilities. All of the buildings in this 1913 photograph have been replaced, but Frederika Manor is still providing a wonderful service to the elderly 100 years after it was founded.

In 1889, some developers had the dream of creating the town of Otay at the southern edge of what today is Chula Vista. To help achieve that dream, the developers built this three-story brick building hoping to attract a manufacturing business. The first and only client was the Otay Watch Works. The Otay Watch Works building was a longtime sight on the southern edge of Chula Vista. It actually made watches for only a very short time. Besides watch-making machinery, they also installed an electric light plant that furnished electricity for the town and the factory. Their first watch was completed in May 1890. By October 1890, however, it was clear that there was not much demand for an Otay Watch, so the factory shut down. Their offices were in the smaller brick building. The budding town of Otay was basically destroyed in the flood of 1916 when the Lower Otay Dam broke upriver. The building survived the flood and was used for a variety of mostly illegal uses (trespassing) until the 1940s. (Courtesy San Diego Historical Society.)

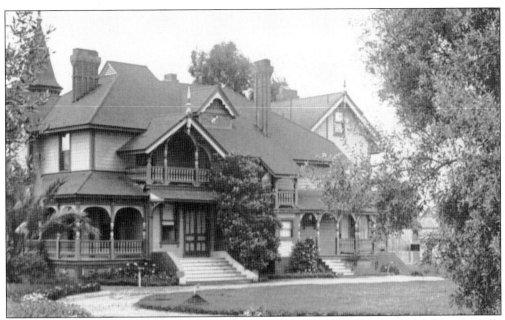

The Herman Hotel, built so long ago, is a building that people find it hard to believe actually existed a century later. It seems so huge for a town of a few hundred people. Beginning with a house built in 1888 at the southwest corner of F Street and Hilltop Drive, the owner decided in 1894 to add 13 rooms and convert it into a hotel for eastern tourists. The hotel burned down in 1914, but the carriage house was converted into a home and still stands.

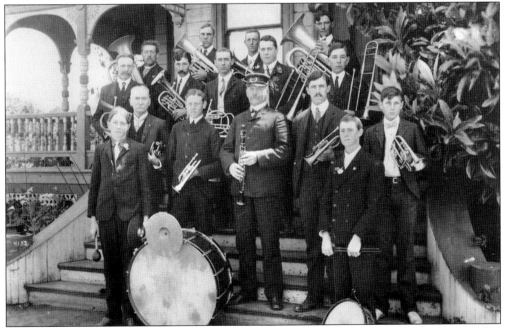

Like any fine hotel of its time, the Herman Hotel had access to a band for the entertainment of its guests. In this case, it was the city band of Chula Vista. All small towns a century ago had a town band. Without television, radio, computers, or iPods in those days, and precious few nightclubs in Chula Vista, a band would have been a nice attraction in an isolated hotel.

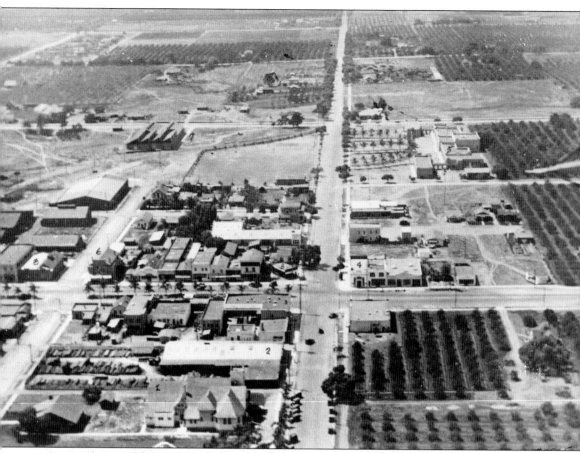

An aerial view of downtown Chula Vista in 1925 looks directly west down F Street toward the bay. Third Avenue crosses the photograph about one-third from the bottom. On the northwest corner of Third Avenue and F Street, the Peoples State Bank (page 89); the Chula Vista Paint Store (page 83); and the building housing city hall, the police station, and the first fire station (page 45) can be seen. On the southwest corner of Third Avenue and F Street is Chris DeBoyer's service station (page 79). At the bottom center of the photograph is the extended Congregational Church (page 70). On the northwest corner of Third Avenue and Center Street is Farrow's General Store (page 42). Fourth Avenue crosses the photograph a quarter-mile west. On the north side of F Street, one can see the F Street School (page 65). The lemon orchard behind the school became its playground. To the south of the F Street School is the Mutual Orange Distributors lemon packing plant before it was enlarged (page 27). (Courtesy San Diego Historical Society.)

# Six

# THE COMMUNITY
# AT PLAY

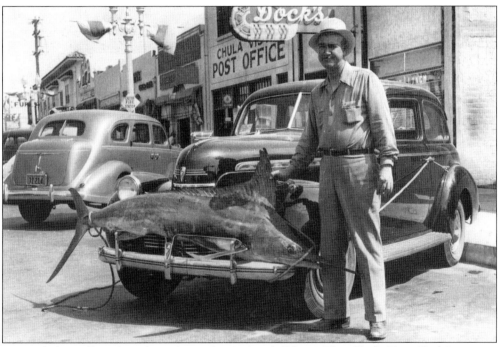

It is said that "all work and no play makes Jack a dull boy." This Chula Vista "Jack," anyway, decided to go fishing. The fish he caught is a marlin. Although not as numerous as decades ago, marlin still live in the waters off San Diego. The automobile in this photograph, a 1938 Pontiac, indicates that this image was probably taken in the late 1930s. Perhaps Jack celebrated by stepping into the bar in Dock's Cocktail Lounge behind him for a toast or two. This view looks north on Third Avenue toward F Street. The Melville building can be seen a few doors to the north.

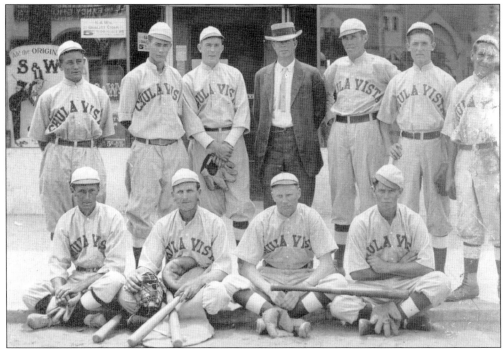

In the 1920s, most towns in the United States had a town baseball team. Chula Vista was no exception. Judging by this photograph, Chula Vista had a starting nine plus one. The players in this photograph were posing on Third Avenue looking east. How do we know? To the right, one can see the reflection in the window of the Congregational Church farther east on F Street.

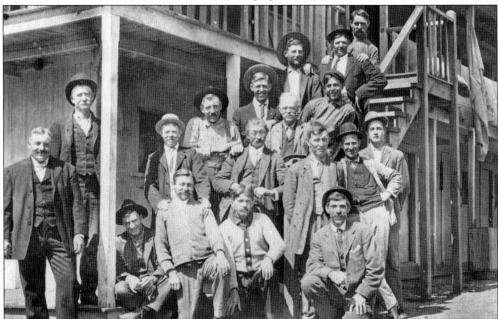

These workers are at rest on the stairs of the boardinghouse used by the San Diego Land and Town Company, the original developer of Chula Vista. The boardinghouse was near the intersection of Third Avenue and K Street.

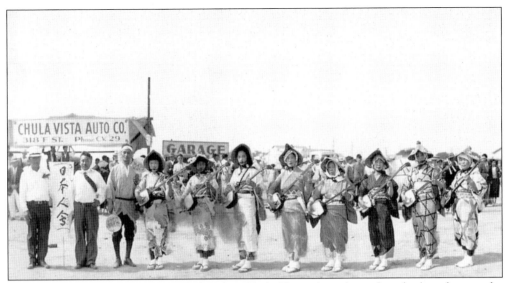

In the 1930s, many Japanese people lived in Chula Vista. As indicated in the last chapter, the Japanese were particularly good at truck farming. Here they are at rest and enjoying a social outing at a picnic in 1937. Many of the women and girls are wearing traditional Japanese clothing. (Courtesy Japanese American Historical Society of San Diego.)

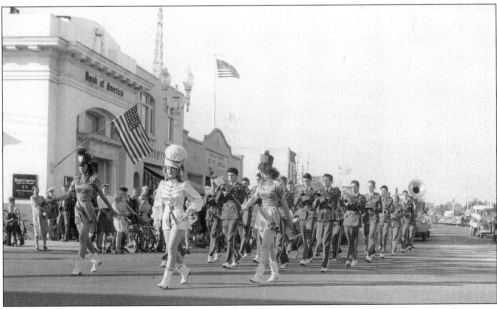

Led by majorette Gwen Ellis, the Sweetwater High School band marches south on Third Avenue in 1945, just crossing F Street. This was probably the first Fiesta de la Luna parade resumed at the end of World War II. The Bank of America moved to new quarters elsewhere on Third Avenue, but the building shown has continued to serve several different uses for residents of Chula Vista.

Muriel Rogers and May Coy, the little girl, stand near the pier of the first Chula Vista Yacht Club. In 1897, the San Diego Land and Town Company, developers of Chula Vista, offered to build a park for residents and a pier for the yacht club at the foot of D Street. The pier was made of iron and heavy flooring from an old railroad wharf in National City. Before 1916, the southern part of San Diego Bay was much deeper than it is now, so sailing boats could race and sail freely. Yacht club members often sailed over to the Brickyard Cove (now Coronado Cays) and farther north to Glorietta Bay at Coronado for picnics. In 1916, the collapse of the Otay Dam washed tons of mud and debris into the southern portion of the bay, and so the southern portion of the bay is only a few feet deep today, except for the channels that have been cut. Later the Hercules Powder Company used the pier for their kelp operations during World War I.

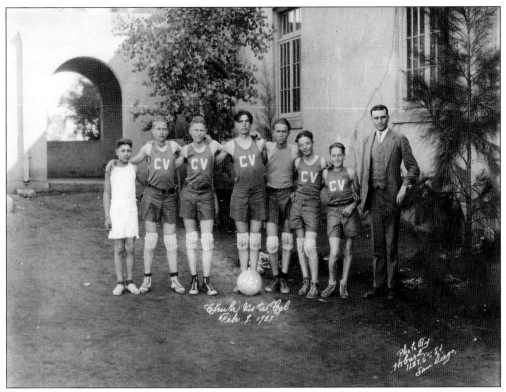

The gentleman at the right is J. Calvin Lauderbach, the principal of the F Street School, posing with the 1927 basketball team. Apparently one of the principal's duties was to coach the basketball team. Today an elementary school in Chula Vista is named Lauderbach School.

Not to be outdone, this is the Chula Vista women's basketball team of 1919. It is not clear exactly what the uniform was supposed to be, except that bloomers are part of it.

In 1921, the San Diego Country Club moved to L Street in Chula Vista from San Diego. The original clubhouse can be seen on the knoll in the distance. Fred Rohr financed the club for awhile, and Ben Hogan, Bob Hope, Bing Crosby, and Pres. Dwight Eisenhower have all played there. Chula Vistan Billy Casper began golf as a caddy there and went on to become a great PGA player. (Courtesy San Diego Historical Society.)

This costume party is having its photograph taken in 1923 in front of the first building built to serve as the Chula Vista Woman's Club at 382 Del Mar Avenue. The building is made of redwood and is as beautiful and well kept today as it was in 1923. Today it has been converted into a duplex.

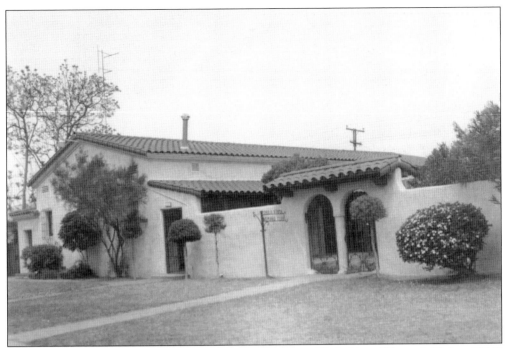

In 1928, the women built this, their second nice but larger Chula Vista Woman's Club at 357 G Street. Recently the woman's club turned the building over to the city, but the building on G Street continues to serve the citizens of Chula Vista in many ways.

In 1930, in order to pay for their new Chula Vista Woman's Club building, the women began an annual Fiesta de la Luna parade. This was an annual event until the early 1970s. The girls, all in Western attire on this float, seem to be having trouble moving the stubborn mule.

These bugle corps marchers in the Fiesta de la Luna parade in 1938 are headed north just crossing Center Street. Note all those on horseback following.

These cars are preparing for the float parade on the grounds of the Chula Vista Mutual Lemon Association's packing plant on Fourth Avenue at Center Street. Any doubt about how active the Chula Vista Woman's Club was in the 1930s?

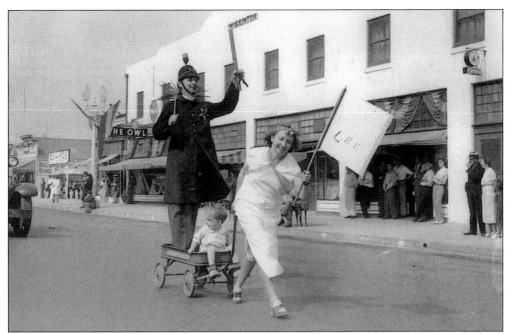

One of the displays in a Fiesta de la Luna parade in 1937 was the Davies family representing Justice and the Handmaiden of the Law. Ethlind Davies, the handmaiden, seems to have gotten the usual woman's job of pulling husband Lowell and son John. It looks like a fire engine is right behind them. Could it be the 1916 "Old Goose" Seagrave?

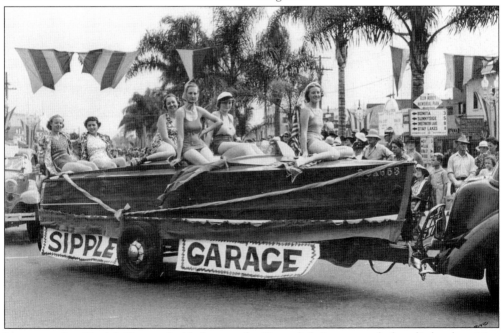

It appears that Sipple's Garage decided to use the Fiesta de la Luna parade for a little advertising with this float. No doubt everyone looked at the girls. This is about 1940 or so, and World War II would soon put a stop to this lighthearted fun. However, in the peacetime that followed World War II, the Fiesta de la Luna was resumed for another 30 years.

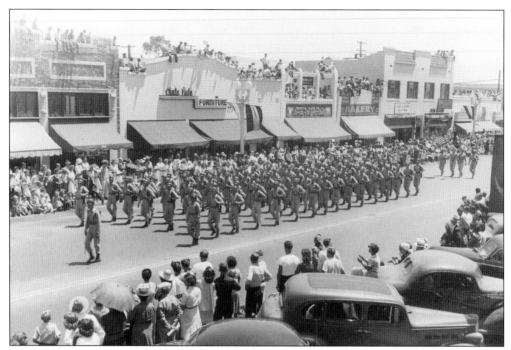

This is what parades looked like during World War II. No tomfoolery here. These are real soldiers with real guns. The troops are marching north on Third Avenue, having just crossed F Street. All the buildings seen in this photograph are still standing.

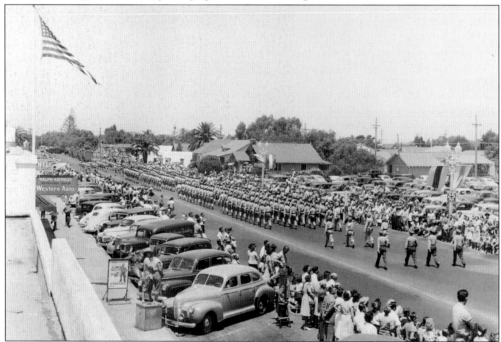

In this photograph, one can see how large the troop contingent was. Note the poster at the lower left encouraging men to join the U.S. Marines. Western Auto was at the corner of Davidson Street and Third Avenue.

## Seven

# FRED ROHR AND WORLD WAR II

Fred Rohr was a sheet metal worker. Moving to San Diego in the early 1920s, he eventually got involved in the aircraft industry. His most notable achievement was making the fuel tanks and sheet metal nose cowling for Charles Lindbergh's *Spirit of St. Louis*, flown across the Atlantic in 1927. Thus Rohr's craftsmanship is forever displayed in the Smithsonian. Rohr poses at right with one of his patented drop hammers. In 1940, he formed his own company, Rohr Aircraft Company, in San Diego to make parts for aircraft manufacturers. In the summer of 1941, just six months before the attack on Pearl Harbor, he built a new factory in Chula Vista. He had about 800 employees. Rohr Aircraft's core product was nacelle systems, the aerodynamic structures that surround airplane engines, including the requisite equipment. By the height of World War II, Rohr Aircraft was employing some 9,800 employees, making nacelles primarily for the B-24 bombers and PBY flying boats being made in San Diego.

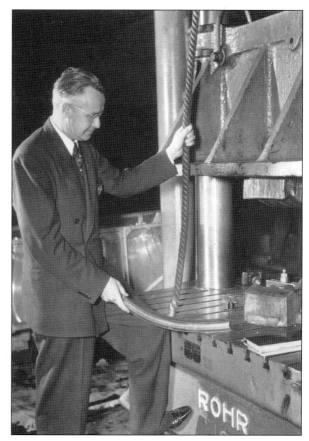

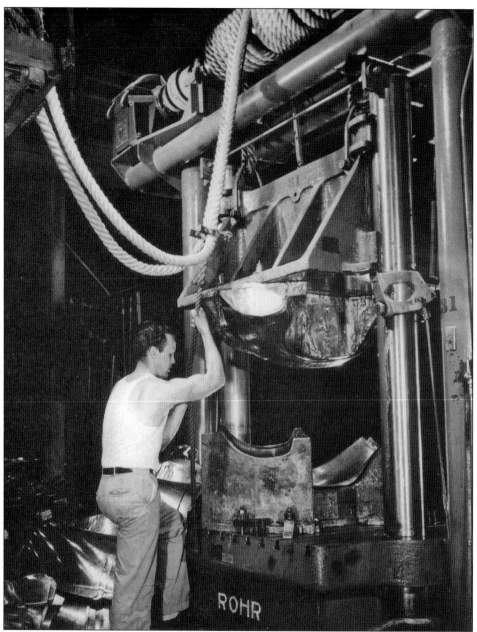

In the 1920s, the exterior surfaces of airplanes were covered with fabric. In the 1930s, it became important to improve the flight characteristics of aircraft because of the service for which they were being used. During World War II, many uses for airplanes as civilian aircraft were discovered. Demand for air transport of passengers and freight became important as did the demand for air shows. In the 1930s, Fred Rohr designed a drop hammer that could be used to form aluminum into configurations necessary in airplane parts. Pictured is one of the larger drop hammer machines. Dies manufactured to the specification required for use in these forming machines required precise design and manufacture to form the proper part configuration. In an airplane power package, as many as 50 percent of the parts require forming. The drop hammer proved to be a great benefit to the business of Rohr Aircraft Company. (Courtesy Goodrich Aerostructures Group.)

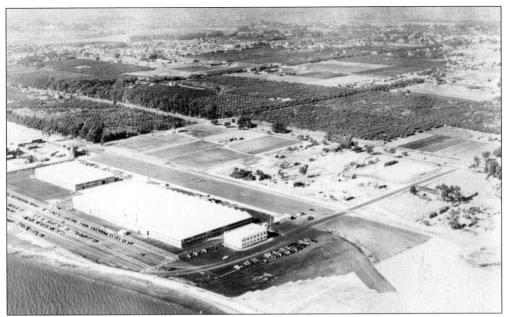

The smaller building to the left, at 37,500 square feet in size, was Rohr Aircraft's first factory building in Chula Vista, as seen in this aerial view of Rohr Aircraft early in 1942. With the advent of World War II, even this new building was far too small. So they built the large, 125,000-square-foot building in the center. They also built a small administration building, the two-story one with windows fronting H Street.

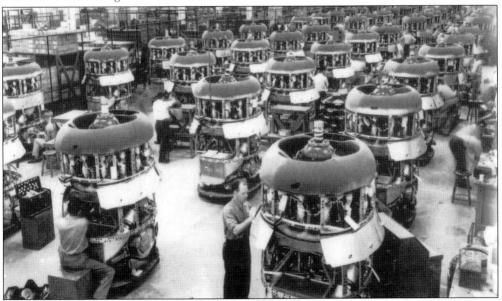

The basic Pratt and Whitney radial engines used on B-24 bombers and PBY Catalina flying boats, shown in this view inside the Rohr Aircraft factory in 1943, were built elsewhere and then transported to Rohr's Chula Vista factory. Rohr then completed the nacelle system of the outside aerodynamic structure and attendant equipment. Rohr called the completed ready-to-install units "power packages." When completed, they were trucked to a Consolidated Aircraft plant in San Diego.

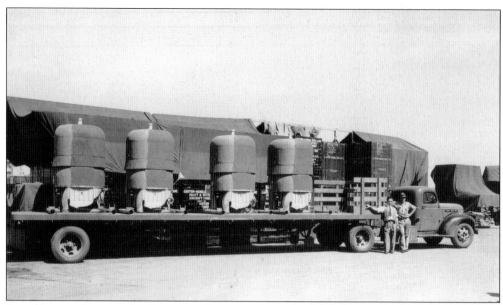

One ship-set—four completed power packages—is shown loaded and on its way to the Consolidated Aircraft factory in San Diego. These engines are ready to be installed directly on to a B-24 Liberator bomber wing. (Courtesy Goodrich Aerostructures Group.)

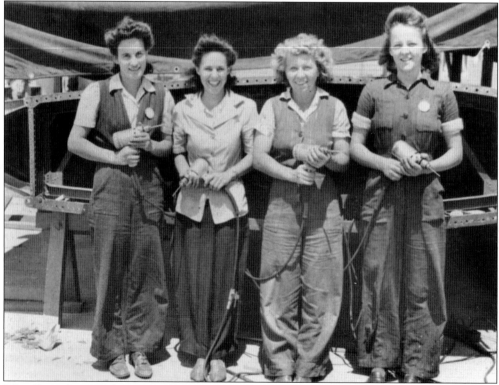

Like all war factories during World War II, Rohr Aircraft soon found that they had to hire women to work in the factory taking the place of men off to war. These "Rosie the Riveters" at Rohr look ready, willing, and perfectly capable of getting the job done. They were.

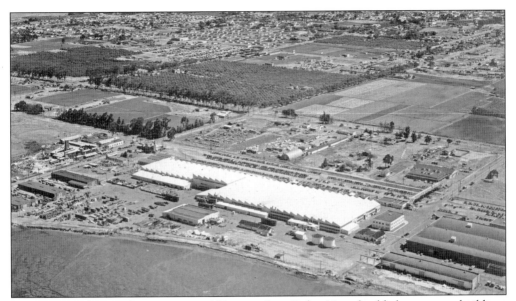

Compared to the aerial view on page 117, notice how Rohr Aircraft added even more buildings on the right edge of the photograph (south of H Street) and even some on the bay side in this aerial view taken in 1945. Employment at Rohr Aircraft increased 12-fold in just a few years during World War II. Note the last vestiges of a lemon grove in the background. Chula Vista's agricultural character would soon be gone.

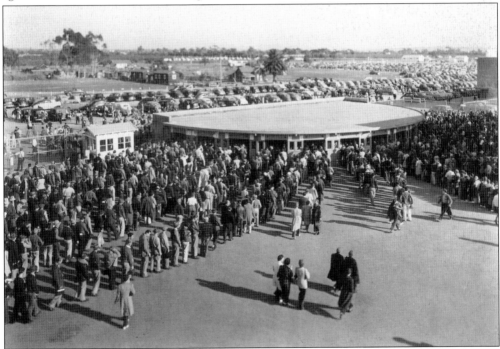

The Rohr Aircraft H Street clock house was where employees clocked out as they came to and left work. On Friday, payday, when they removed their time card to clock out, their paycheck would be behind their time card. This looks like a payday. Note the last houses on Walnut Street, soon to become a parking lot.

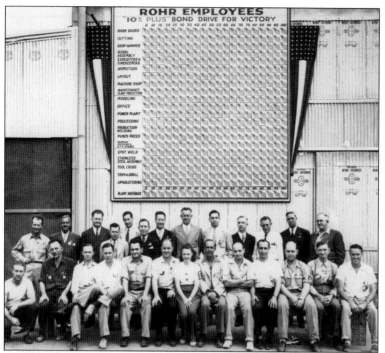

As was happening all over the United States, some of those paychecks went to help the war effort by buying war bonds. There are 21 Rohr Aircraft departments listed on the chart. Everyone could see which departments reached 100 percent of their bond drive goal. A close reading of the chart shows, not surprisingly, that all 21 departments reached 100 percent of their goals. Fred "Pappy" Rohr stands tall in the center.

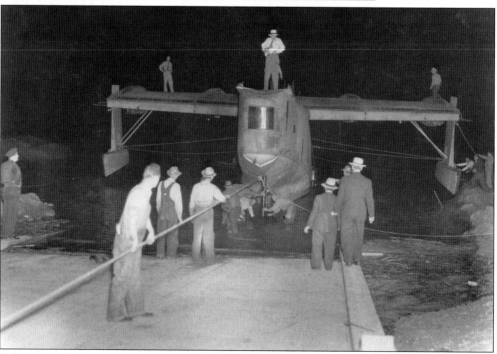

Rohr Aircraft did not manufacture airplanes, but they did overhaul and convert many of them, like these PB2Y Consolidated Coronado flying boats being hauled out of the bay for some special work. These are being hauled up on land so they can be reconfigured to carry more cargo. Burt Raynes is the man standing on the aft end. Raynes was an engineer and eventually succeeded Fred Rohr as president in 1963.

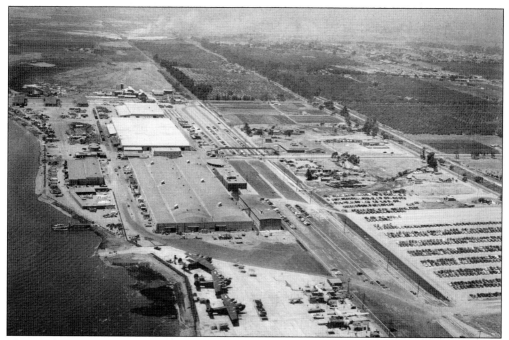

The southern part of Rohr Aircraft's factory (bottom of the photograph) has PB2Y Coronado aircraft awaiting the installation of new engines. Later all of the bay area that can be seen would be filled in, and Rohr factory buildings eventually would cover all the land shown where the seaplanes are and what is the marshy part of the bay.

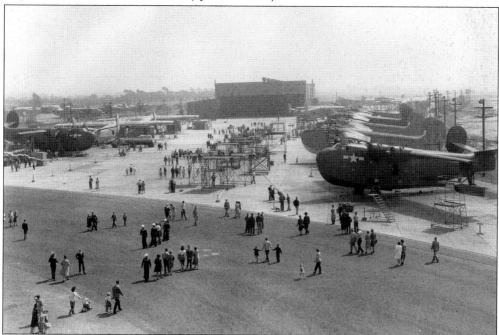

It is Family Day at Rohr Aircraft, and the families of workers were encouraged to come see where their family member worked. Rohr, like Goodrich Aerostructures today, has always gone out of its way to build morale with events such as Family Day.

Sgt. Joe Louis, heavyweight champion of the world at the time, is shown on a tour of the Rohr Aircraft plant in 1943. The army believed that celebrities like Joe Louis could do a lot more for the war effort by building morale on visits such as this one than by being sent into combat.

The Rohr Aircraft Corporation is receiving an Army/Navy E Flag award for excellent performance for the war effort. Presented in 1943, the E Flags were another way of boosting morale by showing the government's appreciation for a plant's war production. The tall proud man in the center in civilian clothes is Fred Rohr.

In the mid-1950s, Rohr Aircraft was still a very large corporation in a relatively small Chula Vista. There were some mutterings around town that Rohr was too dominant in city affairs and that Rohr was not really that important to Chula Vista. So one payday in 1955, Rohr paid its employees in silver dollars. Soon cash registers throughout Chula Vista were clogged with silver dollars.

During World War II, there were continual bond drives to encourage people to buy war bonds at war bond booths like this one on Third Avenue. It was decided to finance the war by borrowing, rather than by raising taxes. This served a second purpose of temporarily absorbing excess spending money that wartime jobs created, thus reducing inflationary pressures. The large book records the local men in service.

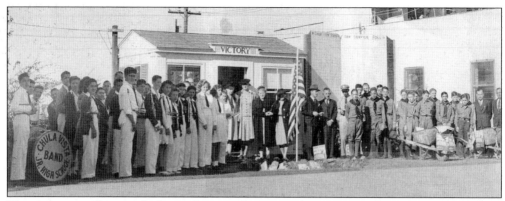

Three wartime efforts on the home front can be seen at this wartime rally at the bond booth on Third Avenue. First, the Chula Vista Junior High School band has no doubt been playing some patriotic music; second, the adults are standing in front of the booth where war bonds are sold; and third, the Boy Scouts on the right have been out collecting scrap metal and perhaps bacon grease and fat.

During World War II, there was a huge demand for wartime housing mostly because of Rohr Aircraft. Two large emergency housing projects were built, one between H and I Streets, where the Chula Vista Shopping Center is now, and the other at the corner of Hilltop Drive and East J Street, where Hilltop Middle School, the fire station, and the elementary school headquarters are now. (Courtesy San Diego Historical Society.)

This wartime housing project was built on the Schertzer family farm between H and I Streets. Called Vista Square, it eventually had more than 1,000 units. The elementary school created for this wartime development, also called Vista Square, still exists on G Street, although none of the wartime buildings survive.

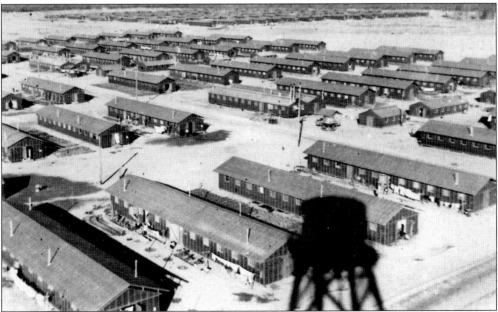

Many persons of Japanese ancestry lived in Chula Vista in the 1930s. In April 1942, they, like all persons of Japanese ancestry in California, Oregon, and Washington, were forced to move to relocation camps in the desert. Most Japanese from the San Diego area, including Chula Vista, wound up in Poston (pictured), a relocation camp located a few miles south of Parker, Arizona. (Courtesy Japanese American Historical Society.)

Following the end of World War II, Chula Vista's character began to change. Because of all the navy and Marine Corps men coming through San Diego and all the war workers coming to the San Diego area, people started to move to Chula Vista in great numbers. Soon lemon groves and celery fields were being plowed under in order to build houses. That, in turn, caused more businesses and schools to be built. Chula Vista was becoming a bedroom community. People lived in Chula Vista, but many jobs were in San Diego or elsewhere. Interestingly many of the developers building on former lemon groves chose to leave one lemon tree in each backyard. So Chula Vista still has some lemon trees that are more than a half century old. The two photographs on this page show typical 1950s housing developments, in this case on and around the Whitney-Mankato circle. (Both courtesy San Diego Historical Society.)

By the 1980s, most of the flat land in western Chula Vista was built out. Beginning in the early 1980s, planned Chula Vista communities like EastLake began to build thousands of houses at a time on the rolling hills of what was then called the "eastern territories." Today EastLake is almost built out, but Otay Ranch is continuing that explosion of new communities. Chula Vista's population grew from 5,000 to 16,000 during World War II and then to 84,000 by 1980. In 2007, the population is 220,000 and counting, with an expected build-out population of 300,000. Still a bedroom community, an urbanization redevelopment program will soon begin on the older west side of Chula Vista. The year 2011 will mark the 100th anniversary of the incorporation of Chula Vista as a city. (Above courtesy Manny Ramirez; below courtesy *San Diego Union-Tribune*.)

# Chula Vista No. 7 in the nation in galloping growth

**By Lori Weisberg**
STAFF WRITER

For any South Bay commuter tied up in traffic during the evening rush

reported.

By comparison, the city of San Diego, with a population of more than 1.2 million, experienced a population increase of only a little more than Chula

# ACROSS AMERICA, PEOPLE ARE DISCOVERING SOMETHING WONDERFUL. *THEIR HERITAGE.*

Arcadia Publishing is the leading local history publisher in the United States. With more than 4,000 titles in print and hundreds of new titles released every year, Arcadia has extensive specialized experience chronicling the history of communities and celebrating America's hidden stories, bringing to life the people, places, and events from the past. To discover the history of other communities across the nation, please visit:

## www.arcadiapublishing.com

Customized search tools allow you to find regional history books about the town where you grew up, the cities where your friends and family live, the town where your parents met, or even that retirement spot you've been dreaming about.